The Sketchbooks of John Samuel Blunt

Deborah M. Child

Foreword by Dian

The Portsmouth Athenæum
Portsmouth, New Hampshire

© The Portsmouth Athenæum
9 Market Square
Portsmouth, New Hampshire 03801
www.portsmouthathenaeum.org

Library Congress 2007928843
Printed in the United States of America
ISBN 0-9794860-4-1

Front cover:
View of the Piscataqua River from Noble's Wharf. Figure 4-30.

Image opposite:
View of Portsmouth from Freeman's Point. Detail of Figure 4-22.

Photography and design by Evelyn S. Lamprey, Portsmouth, New Hampshire • www.eslamprey.com

Printed by Capital Offset Printing, Concord, New Hampshire

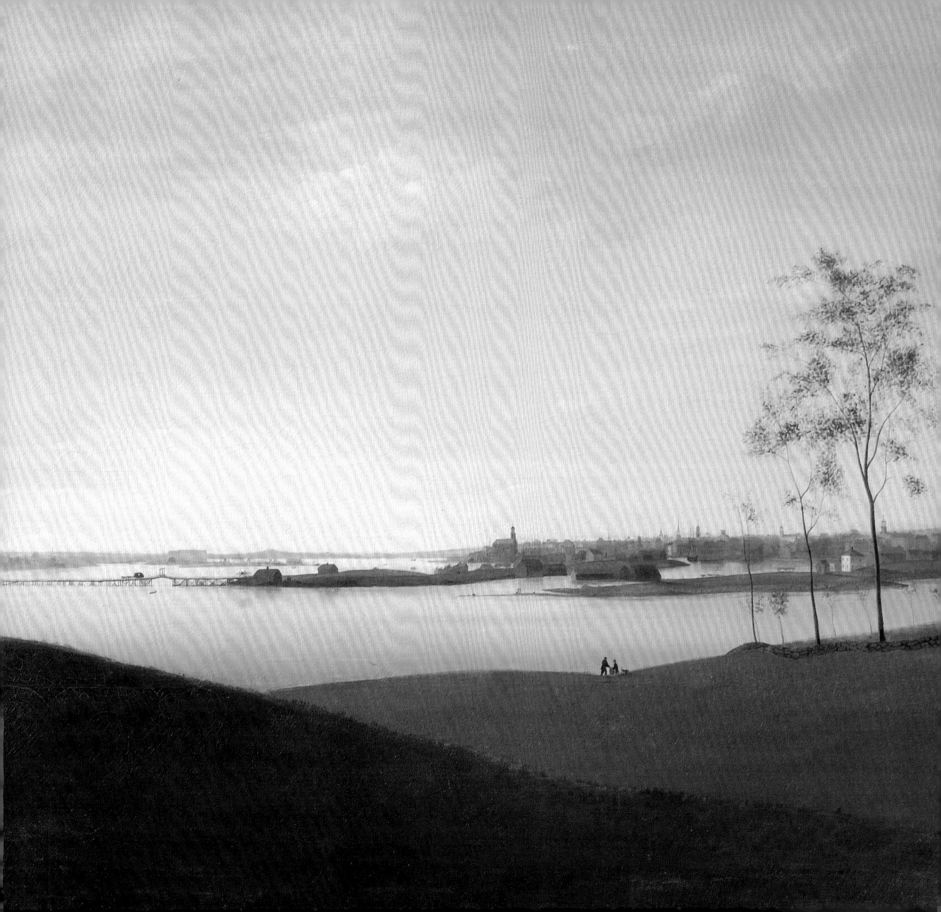

Contents

Foreword by Diana Korzenik, Professor Emeritus, Department of Art Education, Massachusetts College of Art; author of *Drawn to Art* (1985) and *Objects of American Art Education: Diana Korzenik Collection* (Huntington Library Press, 2004)

Acknowledgements

Preface

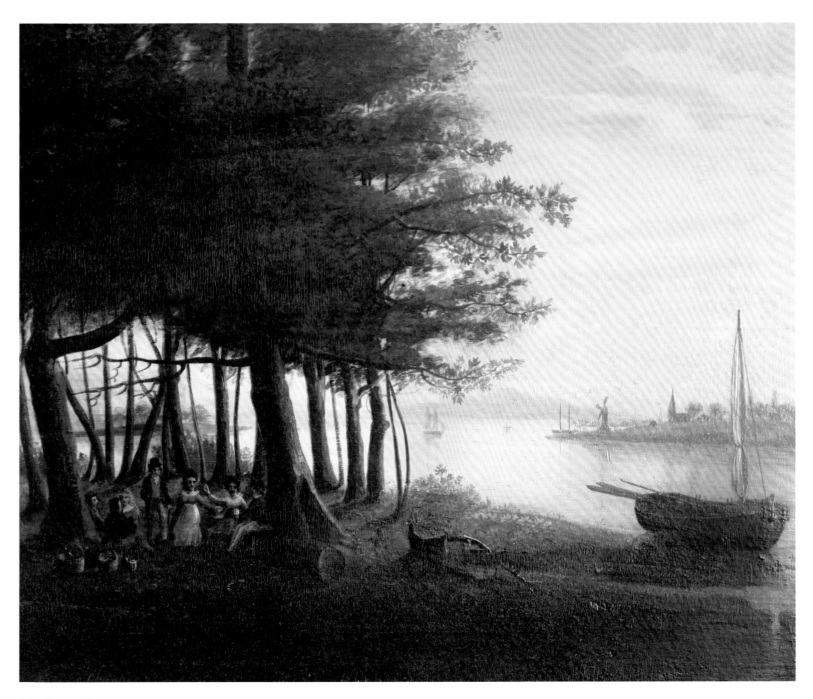

John Samuel Blunt
Picnick on Long Island Sound
Signed on rock at right "J. S. Blunt Pinx. 1823"
Oil on panel
15½ × 19 inches.
Private collection

Foreword

*D*oing historical research on an artist with meager biographical information and few signed works—as in the case of the short life of the painter John Samuel Blunt—requires an ingenious and imaginative researcher. Deborah Child is such a researcher. As you will see, she has accomplished a rather extraordinary feat—a *tour de force*—in her study of John Blunt's life and work. Like a tightrope walker, she had to find, indeed, wind and connect the threads. Then she had to test them to determine their "strength." Were they strong enough "to stand on"? Then she had to perform the feat of walking along the tightrope of her own making. I will explain.

Research begins with a person who is captivated by a subject. That passionate engagement is sometimes a consequence of where that person lives. The scholar has to remove herself from her time and probe into the subject's historical past time. The researcher's quest is to make the art make sense in its place, its time, to know, perhaps—wonder of wonders—the maker's intentions beyond earning a few dollars. There is always a wider story.

Traditional art historical techniques may open up new worlds or may propel one into dead ends. But the clever historical detective will seek out any means, any available sources or technologies that may lead her to a new perception of the specific place and past era under study. So here are the two ends of the tight rope; at one end stands the researcher in her present life, and at the other end is the artist's barely-visible barely-knowable life and objects in past time.

Deborah Child stands at one end. She began life in England. Life brought her to Toronto, and now she lives in the Portsmouth, New Hampshire area. Daily she lives in, loves, and travels in and around the Portsmouth seacoast. She observes the steeples, the bridges, the shorelines and the ever-changing sky and water. These presences are companions in her life. She has also seen and been moved by the nineteenth-century maritime paintings of John Samuel Blunt. They depict his Portsmouth, his loves and travels in and around the Portsmouth seacoast. He also observed the steeples, the bridges, the shorelines and the ever-changing sky and water. So she, in the twenty-first century, set out to meet John Blunt in his early-nineteenth-century life and work. These are the end-points of the long tightrope she had to spin, stretch and walk along in order for her to find and tell us more than anyone yet has known about John Blunt.

Deborah Child used the perfect technique: genealogical research. She is an expert in this under-used, potent tool for art historical investigations. As Ms. Child studied other nineteenth-century painters in New England, identifying the artists and the patrons, she realized this was the way to reach the up-to-now elusive John Blunt. Through Deborah Child's meticulous steps, checking and double-checking, she spun her way to John Blunt and from him to his living descendants.

John Blunt's descendants, like many families in our time, found themselves in possession of objects that have family significance, but about which they knew little. They had few clues as to what was saved and why. It just was there. Enter Public Television's *Antiques Roadshow*. In every city across this nation, long lines of patient men and women, hugging stuff from their attics, wait to consult with an expert about their object—be it a book, an old toy they are holding, or a heavier object they are pulling in a wagon. Everyone asks the same questions: What is THIS? Why did it matter to Aunt Milly? And what is it worth? Trivia or treasure? When Deborah Child learned that a Blunt descendant presented the artist's sketchbook on *Antiques Roadshow*, she applied her keen curiosity to locating the sketchbook's owner.

The rest is history. The result is in your hands. By carefully looking, listening, examining every page she was shown, she has spun a strong tight rope. Deborah asked herself questions, asked me questions, asked everyone who might have answers. Some questions she could answer by studying old maps. She even sought out a surveyor who knew the old terrain in its many incarnations. For Deborah to ascertain whether the marks on Blunt's sketchbook pages actually corresponded to real locations, she consulted experts with topographical, geographical and historical knowledge of the Piscataqua.

Thanks to her imaginative and persistent approach to John Blunt., the material Deborah Child has found will fascinate those who know and love the Piscataqua. But this book is also a gift to the Blunt family and Blunt admirers everywhere. As the love of and the collecting of nineteenth-century American painting has grown, people want to know the diverse artists who loved nature and depicted it long before later generations fell in love with their work.

Diana Korzenik
March 26, 2007

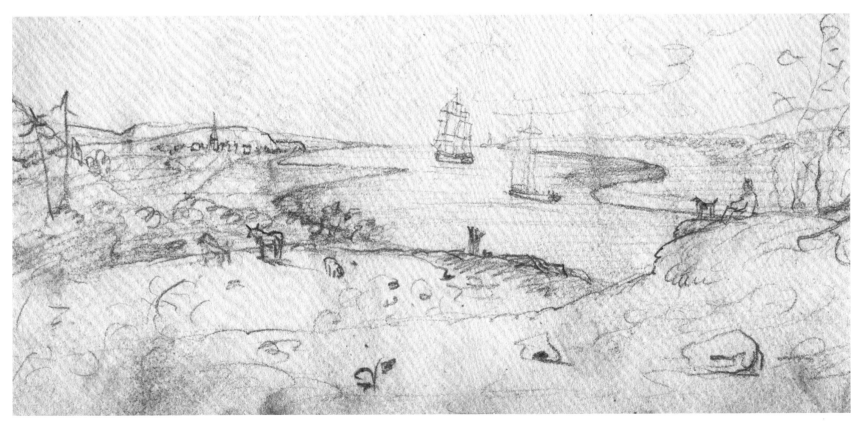

Detail of Figure 2-12

Acknowledgements

THIS PUBLICATION IS DEDICATED TO THE BLUNT FAMILY, many of whom prefer to remain unnamed. Thank you for sharing your stories, your family items, your spirit, and most of all, for preserving the sketchbooks.

I am especially grateful to the late Robert Matteson Blunt, Sr., who placed his family papers on deposit at the Foothills Genealogical Society, Lakewood, Colorado, in 1987. Thanks to his interest in genealogy, I was able to follow the trail which led to this book.

Sponsors of this publication:

Dr. Peter and Nancy R. Beck
Ron Bourgeault, Northeast Auctions, Portsmouth, New Hampshire
Hollis E. Brodrick, Portsmouth, New Hampshire
Geoffrey E. Clark M.D. and Martha Fuller Clark
Arthur M. and Patricia L. Heard
Diana Korzenik
Evelyn S. Lamprey
Bernard & S. Dean Levy, Inc. New York, New York
Marston Family Funds, New Hampshire Charitable Foundation
 Piscataqua Region
New Hampshire Historical Society, Concord, New Hampshire
Linda Jane Rebeck in memory of Margaret Linda Jane Blunt
Randy and Nancy Root, Metamora, Illinois
Jean E. Sawtelle
Peter S. Sawyer, Exeter, New Hampshire
Jay Stewart, Capital Offset Company, Concord, New Hampshire
Elisabeth Bartlett Sturges
Thaxter Swan in memory of Ruth Baldwin Swan
Rosamond Thaxter Foundation
Mr. & Mrs. Richard Thorner, Manchester, New Hampshire
William B. Upton, Concord, New Hampshire
Ed Weissman, Portsmouth, New Hampshire
Sumner and Helen Winebaum
Gary F. Yeaton, Concord, New Hampshire
Susan and Donald Zuckert
Two Friends

Contributors

Michael Baenen
Russell and Dorothy Blount Battersby
Robert Matteson Blunt Jr.
Margaret Scott Carter
Sara Delano in memory of her mother, Libby Delano
Armistead and Louise Dennett
Townsend H. Dunn
Christine Dwyer and Michael Huxtable
Elizabeth Engelbach
Lynne Fox, Fox Imaging, Tilton, New Hampshire
James L. and Donna-Belle Garvin in memory of Dr. Dorothy M. Vaughan
James Hall, Oxford Gallery, Rochester, New York
Wendy Lull
Mr. and Mrs. Keith Morgan
Sue Blunt Mullins
Donald Neiman
Arthur J. Phelan
Merrilee J. Possner
Rodney and Lee Roberts
Ursula and Philip Wright
A Friend

This book would not have happened without the guidance and sustained commitment of Richard Candee; Tom Hardiman; Patricia L. Heard; Diana Korzenik; and Evelyn S. Lamprey, photographer, print and web-designer; Wendy W. Lull, President of the Board of Directors of The Portsmouth Athenæum; Nancy Mulqueen; and my husband Tom—your patience and technical guidance throughout the length of this project has been outstanding and deeply appreciated. Thanks to my Mom who purchased the laptop on which this book was created, and to my sister Christa, Jon, Tyler, and Carolyn for their ongoing support.

Special thanks to Nancy Beck for her skillful editing. Richard Candee, Tom Hardiman, Patricia L. Heard and Carolyn Marvin kindly read the text and made useful and insightful comments throughout. Rose C. Eppard served as galley proofreader.

I would also like to extend my gratitude to surveyor Gerald H. Miller. His expertise in the topography of New Hampshire and his knowledge of the historic maps of this region were critical for identifying the sites that Blunt sketched in 1821.

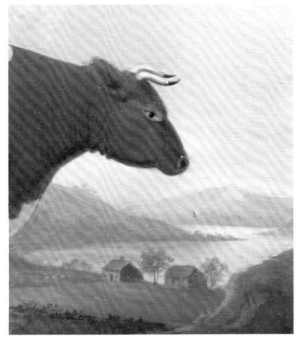

Above: Detail of Figure 5-9

Contributing Organizations:

Rachel Crockett, Birmingham Museum and Art Gallery, Birmingham, England

Peter Benes, Dublin Seminar Project, Boston University, Boston, Massachusetts

Miriam Steward, Fogg Art Museum, Cambridge, Massachusetts

Elizabeth Burdick, Jerry Sherard, Foothills Genealogical Society, Lakewood, Colorado

Elizabeth Aykroyd, Richard Hureau, Betty Moore, Tuck Museum,
Hampton Historical Society, Hampton, New Hampshire

Nancy Carlisle, Lorna Condon, Elizabeth Farish, Jeanne Gamble, Richard C. Nylander,
Adrienne Sage, Historic New England, Boston, Massachusetts

Anthony Moore, Art Restoration, York, Maine

Jay S. Williamson, Nancy Thurlow, Newburyport Historical Society,
Newburyport, Massachusetts

Deb Schulte, Ruth Lanham, Courtney MacLachlan,
New Castle Historical Society, New Castle, New Hampshire

New Hampshire Charitable Foundation Piscataqua Region

James L. Garvin, Peter Michaud, New Hampshire Division Historical Resources,
Concord, New Hampshire

Wes Balla, Bill Copeley, Douglas Copeley, Donna-Belle Garvin, William P. Veillette,
New Hampshire Historical Society, Concord, New Hampshire

Susan Kress Hamilton, Phineas Press, Portsmouth, New Hampshire

Tom Denenberg, Erin Damon, Portland Museum of Art, Portland, Maine

Susan Kinstedt, Robin Silva, Ursula Wright of The Portsmouth Athenæum,
Portsmouth, New Hampshire

John Bohenko, Nancy Carmer, David Moore, Suzanne M. Woodland,
Portsmouth City Hall, Portsmouth, New Hampshire

John Mayer, Peter Narbonne, Sandra Rux, Stephanie Seacord,
Portsmouth Historical Society, Portsmouth, New Hampshire

Nicole Cloutier, Richard Winslow, Portsmouth Public Library,
Portsmouth, New Hampshire

Louise Tallman, Rye Historical Society, Rye, New Hampshire

Kimberly Alexander, Rodney Rowland, Tara Weber, Laurence Yerdon,
Strawbery Banke Museum, Portsmouth, New Hampshire

Mr. and Mrs. Abbot W. Vose, Robert C. Vose III, Courtney Kopplin,
Vose Galleries, Boston, Massachusetts

Warner House Association, Portsmouth, New Hampshire

I would also like to thank:

John Andela
Merrill Black
Tom Connors
Jack Davidson
Ronan Donohoe
Michelle Dubois
Howard Fertig
Marlon S. Frink
Joseph W. P. Frost
Paul F. Hughes
The Little family
Debora Dyer Mayer
Lorraine Stuart Merrill
Jane C. Nylander
Jane Molloy Porter
Overton Robertson
Christopher and Tay Tahk
David A. Taylor
Sherry Wood

Finally, I would like to make a tribute to the late Russell A. Lamprey: "This is the book. It's the story that I know."

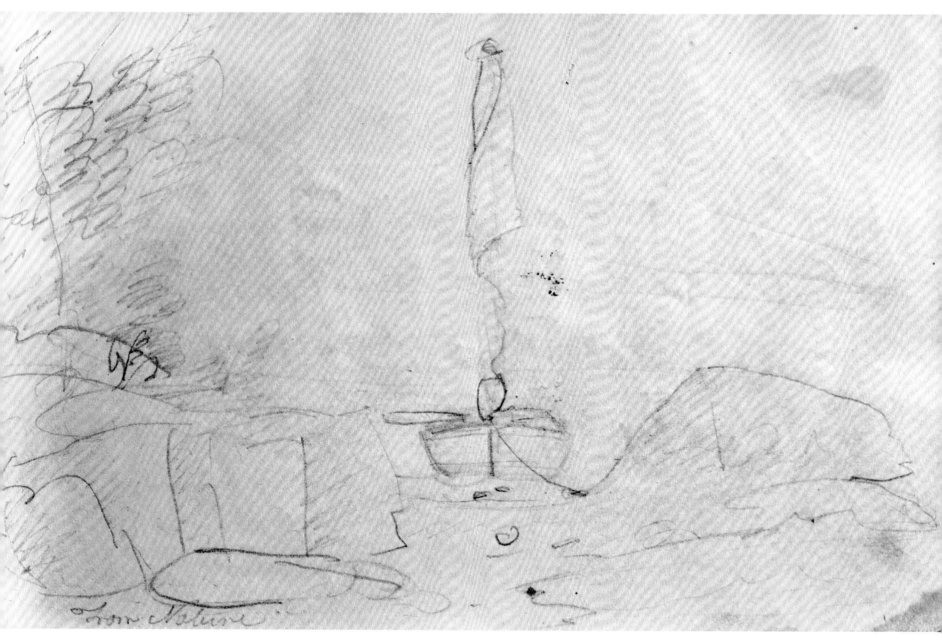

1821-35
"From Nature"

Preface

*C*uriosity got the better of me. Researching the life and career of John Samuel Blunt (1798–1835) has taken me on a journey I did not anticipate. Nina Fletcher Little noted his skill as a landscape and marine artist in 1948, as did Dr. John Wilmerding in 1968. But it was Dr. Robert Bishop who, in 1980, assigned a superb body of portraiture to his *oeuvre*, something that bears further study. Today, with two sketchbooks in hand, I find myself at an unexpected juncture. Instead of portraiture and provenance searches, I have become immersed in a rich tapestry of landscapes and seascapes based upon studies "From Nature."

The earliest surviving sketchbook first surfaced in 2001 on the Public Broadcasting System's *Antiques Roadshow* in a Colorado segment, when viewers were shown the sketchbook along with portraits of the artist and his wife. Appraiser Carl Crossman of Northeast Auctions, Portsmouth, New Hampshire, examined the sketches and noted their Piscataqua content. This revelation piqued my interest in Blunt, but it was not until 2005, when I traced the artist's family line through his son Mark Leonardo Blunt, that I located this sketchbook, the earliest known, along with a second one, previously unknown to scholars, which dates to 1830.

Interpreting these sketchbooks, published here for the first time, has been tremendously rewarding. From these precious pages, we glimpse Blunt's hand working with rhythm and fluidity as he wields his pencil and watercolor brush. We also understand what interested Blunt artistically at a pivotal time in his career. Finally, his sketches offer tantalizing glimpses of what the Piscataqua region looked like when he was living here in 1821. As this is the region in which I live, I feel Blunt has literally opened my eyes anew to nature. I wish the same for you.

Deborah M. Child
February 2007

Chapter I
Who was John Samuel Blunt?

*J*ohn Samuel Blunt (1798–1835), known as "Sam," to his family and friends, was born in Portsmouth, New Hampshire.[1] He was the eldest son of Mark Samuel Blunt and Mary Drowne. He came of age during a trying time in the city's history. Following a brief period of prosperity from 1790 to 1807, Portsmouth's days as a major port on the eastern seaboard were numbered. A series of devastating fires in 1802, 1806 and, most serious, in 1813, demolished much of the center of the city, leaving many residents homeless and impoverished, their businesses destroyed. As the state of New Hampshire slowly industrialized, and roads were upgraded and expanded; goods would eventually be moved through to Boston, with proceeds going directly into the pockets of Boston merchants.

Trying times could describe Blunt's early childhood. His mariner father's long absences from home left the family feeling anxious about his welfare as well as about the family income. In 1811, his grandfather Samuel Drowne, once a prominent goldsmith and silversmith and a pillar of the community, was placed under guardianship for intemperance and idleness.[2] Three of Blunt's siblings died in early childhood (Appendix 2). In the fire of 1813, his family suffered losses to their State Street home. At that time, his father Mark was serving in the war as the lieutenant of the privateer *Portsmouth*. In January 1815, right after peace with Britain was declared, the *Portsmouth* and all those aboard, including Blunt's father, were lost off the coast of Madeira, Portugal.

The artist studied with Master Eleazor Taft at the local high school on State Street in Portsmouth.[3] Taft, a classically trained scholar and a graduate of Brown University, instructed his students in reading, spelling, writing, geography, grammar, natural philosophy, mathematics, and the Latin and Greek languages. Beyond his studies with Taft, little is known of Blunt's formative years. His earliest surviving work is an 1810 penmanship document (Figure 1-3) done at the age of twelve. His control of the pen was masterly even at this stage and shows that his eye and hand coordination were marvelously developed. This calligraphic sample of his work suggests he and others recognized his abilities.

Figure 1-1
John Samuel Blunt
Self-portrait
Oil on canvas
30¾ × 26¾ inches
Collection Randy and Nancy Root
Photo: StudioAlex Photography

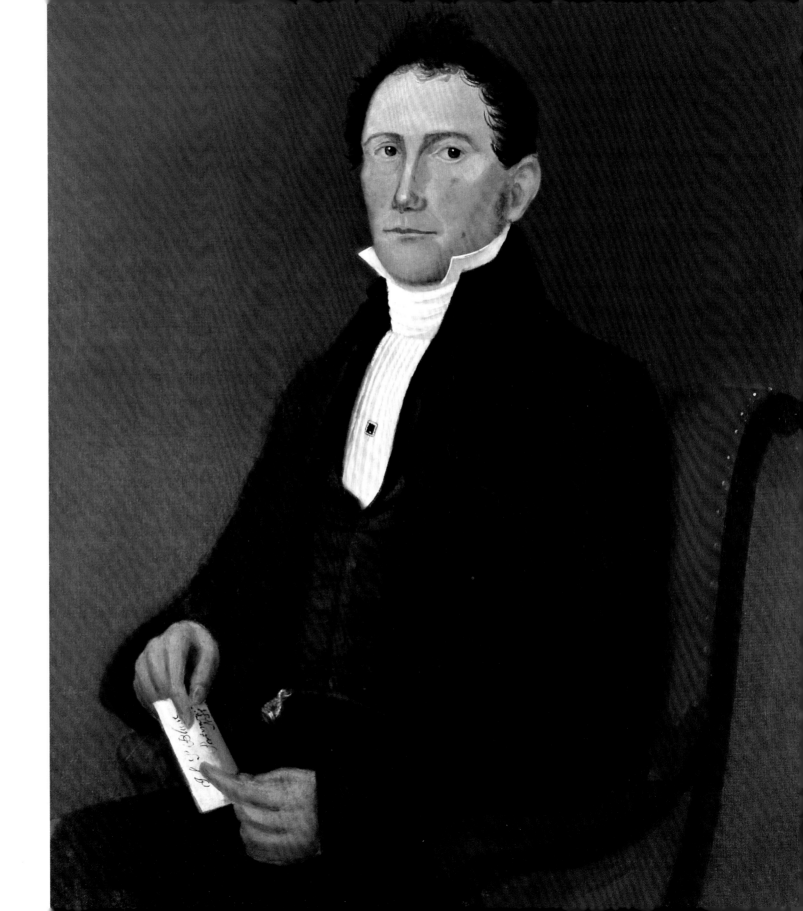

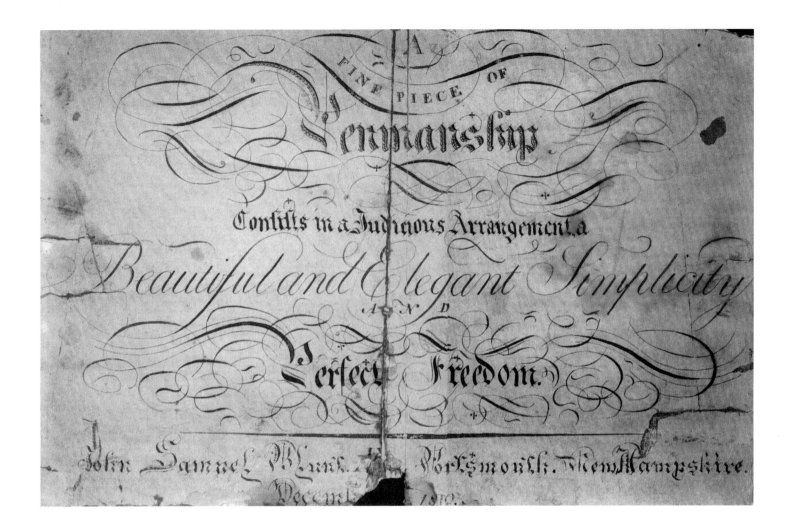

A FINE PIECE OF *Penmanship* Confists in a Judicious Arrangement, a *Beautiful and Elegant Simplicity* AND *Perfect Freedom.*

John Samuel Blunt Portsmouth New Hampshire
December 1810.

Facing page:
Figure 1-2
John Samuel Blunt
Manuscript Ledger Day Book with entries
1826–1835, p. 120
The Portsmouth Athenæum, S855
A close comparison of the letter "John
S. Blunt, Portsmouth, New Hampshire"
(detail Figure 1-1) with handwriting
samples from this ledger book confirm
the portrait was painted by the artist.

This page:
Figure 1-3
John Samuel Blunt
Penmanship document
Dated December 1810
Pen and Ink Drawing.
9 × 14 inches
Private Collection
Photograph courtesy of owner

By 1816, Blunt was serving an apprenticeship in the Boston workshop of John Ritto Penniman (born Milford, Massachusetts 1782–1841) which provided quality ornamental work for clockmakers, furniture makers, carriage makers and local printers. "While not a fine art academy, Penniman's shop was a place of opportunity for young artists of ambition. There they learned useful painting skills and commercial applications that would equip them to earn a living as an artist."[4] Thomas Badger (born Wakefield, Massachusetts, 1792–1868), Alvan Fisher (born Needham, Massachusetts 1792–1863), Charles Codman (born possibly Boston, Massachusetts, c.1800–1842), and Nathan Negus (born Petersham, Massachusetts, 1801–1825) all served there.

From the outset, it was apparent that Blunt was not just interested in learning the mechanics of the trade.[5] In 1819, he joined Negus and other colleagues to form a "society for the instruction of young artists," which they coined the Pennimanic Society. The group of nine met monthly to hear discourses on art, visit art centers like the Gallery of Fine Arts, the New England Museum and the Artists' Association Hall, and to see art collections in private homes.[6]

How much influence Alvan Fisher, one of the first of Penniman's apprentices to pursue landscape painting in earnest, might have had on Blunt is clearly beyond the scope of this publication. However, Blunt's choice of subject matter, locations, the emphasis on sky and atmospheric effects in his landscapes, the scale and manner of the staffage figures which animate his landscapes appear to be modeled on Fisher. As Fisher wrote in one of his notebooks, "Make sketches from nature of everything and trust not to memory;" perhaps he was the one who first inspired Blunt to fill his sketchbooks with drawings "From Nature."[7]

Upon the completion of his apprenticeship at the age of twenty-one in 1819, Blunt traveled up the Merrimac River with his colleague William P. Codman (born Boston 1798; active 1819–1831; died Brentwood, New York, 1878). Blunt reportedly kept a diary from this boating trip which indicates his focus was landscape painting and house portraits while Codman's was portraiture.[8] Other than his Seal of New Hampshire painted for the State House in Concord (Figure 1-4), no other works by Blunt from this trip have been identified.

Blunt returned to Portsmouth where, in 1821, he advertised his skills including portrait, ornamental, sign and glass painting in the local papers. That fall, he married Esther Peake Colby, a daughter of Joseph Colby, a Boston carpenter and housewright. Shortly thereafter, the first of their five children was born and the couple purchased the westerly half of a three-story house on Pleasant Street. The easterly half was purchased and occupied by Blunt's widowed mother and his brothers Mark and Alfred.[9]

On April 5, 1825, the artist advertised in the *New Hampshire Gazette* that he was proposing to open a painting and drawing school, provided sufficient number of scholars could be obtained.[10] December 23, 1826, he posted a notification in the *Portsmouth Journal* that he was removing his painting establishment from Daniel Street to the corner of Court and State Streets.[11] In the new premises, he gave art lessons as well as held a series of exhibitions of his work for which he charged an entry fee of one dollar.[12]

Figure 1-4
John Samuel Blunt
Seal of New Hampshire
Signed "John S. Blunt 1819"
Oil on panel. Height 52 inches
New Hampshire Historical Society, 1966.550.5
Photograph courtesy of the New Hampshire Historical Society

This sign incorporates the seal design of the state of 1784, and appears to have been made to commemorate the completion of the New Hampshire State House, built between 1816 and 1819. Its shape was modeled upon the gallery clock made by Timothy Chandler (1762–1848) commissioned for display in the Senate Chamber. The State House continued to interest Blunt as he sold prints of this building at his painting room on Daniel Street, Portsmouth, New Hampshire (*New Hampshire Gazette*, January 1, 1822).

Securing an adequate income continued to be a challenge for Blunt. In 1827, an exhibition of his paintings was held at The Portsmouth Athenæum. The whole lot, valued at $130, was disposed of by lottery tickets sold for one dollar each.[13] In 1828, he held an especially ambitious exhibition of paintings which included full-length portraits by *Copely* and other distinguished artists as well his own landscape paintings.[14] He also submitted his *View of Winnipiseogee Lake* to the Boston Athenæum, where it was exhibited in 1829.[15] The next year, he was living with his wife and children on Castle Street in Boston in rental property owned by his father-in-law, Joseph Colby. He also secured studio space on Cornhill Square, a large brick block built in 1809 in the heart of the commercial section of Boston.[16]

Subsequent entries in the JSB 1826 Account Book indicate his clients were still mostly fellow craftsmen. As he remarked in a letter from Boston, dated August 23, 1832, "…business is horrible dull here."[17]

His passion for art remained, but buyers had yet to arrive. Even Alvan Fisher, considered by many to be the leading American landscape artist at this time, was having problems:

> Some of this gentleman's Landscapes have been exhibited at the Academy of Arts, Philadelphia. They are highly commended. So they were here, but no one bought them. Meanwhile Fisher starves. Boston gets all the credit, whilst the painter is wearing himself to a shadow.
>
> *Boston Transcript*. May 10, 1831.[18]

In 1835, Blunt packed up his studio, sold off his paintings and headed west, traveling alone (Figure 1-5). Perhaps he had been lured by the promise of cheap land. At that time, the Galveston Bay and Texas Land Company, established in 1830 in New York, had an office in Boston to promote land sales in Texas. Blunt might have also read David Woodman's *Guide to Texas Emigrants*, printed in 1835 by M. Hawes for publishers at 81 Cornhill Square, Boston. The publication included a copper-engraved plate *The Buffalo Hunt*, based on a painting by Alvan Fisher, his colleague and possible mentor, and engraved by W. E. Tucker. If the literature was any indication, becoming an independent farmer and rancher would be his key to success.

Few details of his journey are known. In his last letter to his wife, addressed from Natchitoches, Louisiana, and dated July 1, 1835, he related "my health has been good on my journey, excepting at Cincinnati where I was quite unwell…I shall get through with my business in Texas as soon as possible as I feel anxious to return to Boston. I have not seen much game, as yet, but expect to find plenty in Texas."[19]

On July 17, 1835, Blunt arrived at the land record office in Nacogdoches, Texas. There he signed a petition giving him title to over four thousand acres of land in Houston, on the condition that he and his wife and five children would work the land for at least four years.[20] Alas, this was not to be. On August 25, 1835, Blunt died of yellow fever on the ship *Ohio* while en route home to Boston.

An estate inventory valued his personal property at a modest $83.50, including five framed prints at $2.25. The highest appraisal value assigned was for "electrical machines" valued at $30.00.[21] No description of the machines was included. Based on technology of the time, they were undoubtedly hand-operated apparatuses that generated an electrical current, possibly used for metal-plating frame plaques or clock hands. As Blunt had earlier invoiced Dr. William King, a manufacturer of static electrical machines and lightening rods with an establishment on Cornhill, for "drawing electrical equipment," perhaps the machines were part of his pay.[22]

Rather than emigrate to the Mexican territory of Texas, his widow Esther chose to remain in Boston and raise her five children. By 1850, she and her three youngest children were sharing a household with her daughter Frances and Frances's engineer husband, Stephen Woodworth, in Boston.[23] In 1859, Esther's youngest son, Mark Leonardo, a printer by trade, joined the Boston Trade Company and headed west to settle in Golden, Colorado.[24] By 1860, Esther was helping her widowed daughter Frances run a boarding house in Worcester, Massachusetts.[25] After Frances's death in February 1872, Esther moved to Milford, Massachusetts, where she lived with her eldest son, Michael Angelo, a printer and publisher, until her own death in August 1872.[26] By this time, contact between family members on the eastern seaboard and their Colorado cousins was mostly limited to correspondence.[27]

By the late nineteenth-century, knowledge of Blunt's artistic abilities was nearly lost to all but his descendants. Many of his works were scattered far and wide,

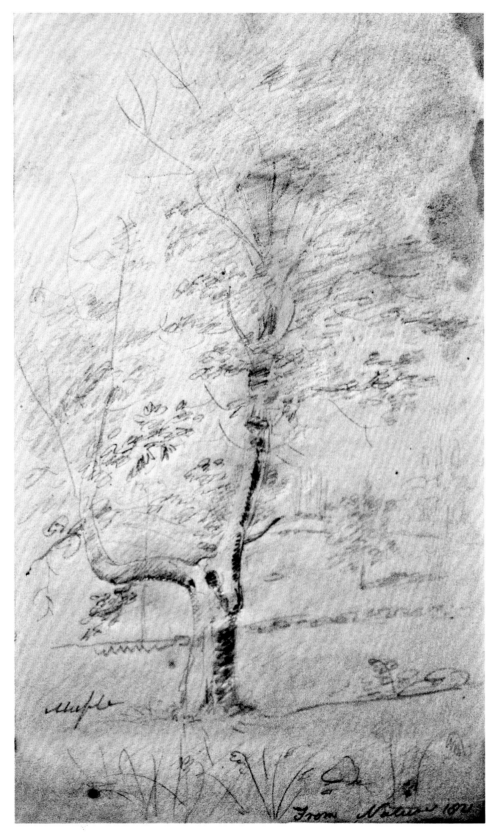

and to this day they remain the subject of much speculation and uncertainty.

Twentieth-century critical interest in Blunt began with a 1947 exhibition of New England paintings held in Boston. One newspaper review illustrated a signed and dated Blunt landscape, and the critic Dorothy Adlow observed:

> This artist was virtually forgotten; in scant records we can find of him, his name is "Joseph." Yet collectors are outbidding each other for the canvases of this American primitive. There is an airiness, a silvery charm, a fragrance and spontaneity to a Blunt landscape that is delectable….John Blunt was the born artist with native grasp of principles.[28]

The following year, prodigious art researcher and connoisseur Nina Fletcher Little published her landmark article "J. S. Blunt, New England Landscape Painter" in *Antiques*, bringing the first scholarly attention to his abilities as a marine and landscape painter.[29]

Then, in the 1970s, interest in Blunt as a portrait painter was sparked when Robert C. H. Bishop identified him as the Borden Limner, a name first coined for the artist who painted the portraits of Captain Daniel Borden and his wife Mary B. Jenney, of New Bedford, Massachusetts.[30] This was the subject of Bishop's doctoral dissertation, entitled *The Borden Limner and His Contemporaries* (University of Michigan) and an exhibition by the same name at the University of Michigan Museum of Art (Ann Arbor, Michigan, 1976–1977). His research, which involved close examination of some 2,200 portraits, culminated in an exhibition of over fifty portraits which he attributed to Blunt: *John Blunt: the man, the artist and his times* held at the American Folk Art Museum, New York, New York, in 1980.[31]

With the exception of the artist's self-portrait (Figure 1-1), where the sitter is clearly identified by the letter he is holding: "John S. Blunt, Portsmouth, New Hampshire" (detail Figure 1-2), none of the portraits shown were signed or dated or accompanied by documentation supporting the Blunt attribution. The closest link Bishop found was a similarity between the lettering present in the globes in a few of

the portraits with that of documented fire buckets by Blunt and entries in the John S. Blunt Account Book, December 1819–October 1826, hereafter known as the JSB 1819 Account Book.[32] These findings in conjunction with portraits of Leonard Cotton and his wife, Borden sitters, and Cotton's citation as a client in that Account Book, prompted the hypothesis that Blunt was the Borden Limner.[33] Despite Bishop's best efforts, the identification of Blunt as the Borden Limner remains primarily a stylistic one.

Given the fact that the artist signed and dated his landscapes and marine paintings but not his portraits, a catalogue raisonné on this artist then commenced. This project, under the sponsorship of The Portsmouth Athenæum, would provide a complete listing of all the work ascribed to this artist. Since 2005, earlier known manuscripts have been reexamined and the following items have been located: the sketchbook shown on the *Antiques Roadshow*, a second heretofore unknown sketchbook dated 1830, his Manuscript Ledger Day Book with entries 1826-1835, and two John Blunt autographed letters. Although none of the cited items relate to the portraits attributed to the Borden limner, they do provide critical factual information about the artist and new images for reexamining this artist's career.

Significance of the Sketchbooks

From his sketches, it is apparent John Samuel Blunt studied nature firsthand as he developed subject matter for his paintings. As some of the sketches are dated 1821, he was clearly keeping abreast of the new ideas and trends evolving in landscape painting in America at that time. Nature was not just topographical subject matter to be replicated in paint or on paper. Rather, the artist combined elements of observed nature with flowing rivers, distant ruins and mountainous views to create timeless, poetic landscapes that conveyed the deeper meaning of life. Such an approach to landscape painting anticipates the two major schools of landscape painting in America—the Hudson River school and the White Mountain school.

Like Alvan Fisher, who filled his sketchbooks with landscape studies as early as 1816, Blunt drew inspiration from nature throughout his career. Even as he was packing up his studio in Boston, he noted that his views of Niagara Falls, the White Mountains and Boston Harbor "...were all from original drawings taken at the several places." (Figure 1-6)

For Blunt, the ever-changing effects of light and air in his landscapes were of special interest. His ability to capture these effects accounts for the veracity of his views. It also invests his paintings with a meaning and resonance that goes well beyond their subject matter. How he accomplished this is evident from careful analysis of his drawings found in these two sketchbooks.

As we examine these sketchbooks in detail—observing their provenance, their subject matter, how the drawings were incorporated into his paintings, and how they fit within his *oeuvre,* it will then be possible to approach the wider story. What were the artist's intentions?

Facing page:
Figure 1-5
1821-17 *Maple* "From Nature 1821"

This page:
Figure 1-6
Daily Evening Transcript
Boston, Wednesday Evening, March 11, 1835
(Vol. VI, No. 1404)

REMOVAL. PAINTINGS FOR SALE. The subscriber intending to remove from Boston about the 15th of April next, offers for sale a number of Paintings; among which are Views of Niagara Falls, Lake Winnipiscogee, Notch of the White Mountains, and several views in Boston Harbor—all from original drawings taken at the several places. Also a variety of Fancy Pieces, Landscapes, Sea Views, Fruit Pieces, &c. They can be seen for a few days at Mr Nathaniel Ring's Looking Glass and Picture Frame Manufactory, No 63 Cornhill (late Market street.) His friends and the public are respectfully invited to view them.
N. B. Those persons who have demands against the undersigned are requested to present their bills for settlement, and those indebted will please call and settle the same previous to that time. JOHN S. BLUNT.
march 9 M&Wta8 No 54 Cornhill.

Provenance of the Sketchbooks

The 1821 Sketchbook

What initially appeared to be an intact sketchbook is actually an assembly of three separate sketchbooks that have been rebound with an additional five pages. In its current configuration, the sketchbook (Figure 2-1) has paste-grained, paper-covered boards, a leather spine and four unequal signatures. Several pages from the three sketchbooks bear the partial watermark of "GOODWINS," a Connecticut papermaker active from 1815 through 1836. This is consistent with the 1821 date on some of the sketches.[34]

The first five pages of the book are of different woven paper than the other three sections. A handwritten label "Mrs. L. C. BLUNT" was once pasted on page two directly over the heads of the two gentlemen in the carriage. Undoubtedly, these pages were selected for inclusion in the rebound sketchbook by Mrs. Laurence C. Blunt (1880–1961) (Appendix 2). One drawing is of a courting couple seated in a landscape, possibly chosen to represent Esther and the artist who were married in Boston in 1821 (Figure 2-3). The

second and fourth sections contain fourteen pages each and are side-stitched. The third section has seventeen pages and it is unclear how they are sewn in.

Although it is not known whether these sketches had always been kept together, they were in the possession of the artist's family in Colorado by the mid-1950s. The artist's grandson Laurence and his wife, whose label had been pasted in the book, were immensely interested in their New England ancestry and purchased a number of family heirlooms.[35] Upon Mrs. Blunt's death in 1961, the sketchbook passed to their younger son Robert Matteson Blunt, who was also very interested in his family history.[36] Upon his widow's death, the sketchbook was given to the current owner, along with early nineteenth-century portraits of the artist and his wife.

This sketchbook consists of one hundred studies in total, three with watercolor highlights, and one pen drawing. Their breadth and scope are equally rare, as they embrace a variety of themes—nautical, landscapes, figural and fancy studies, as well as studies after other artists.

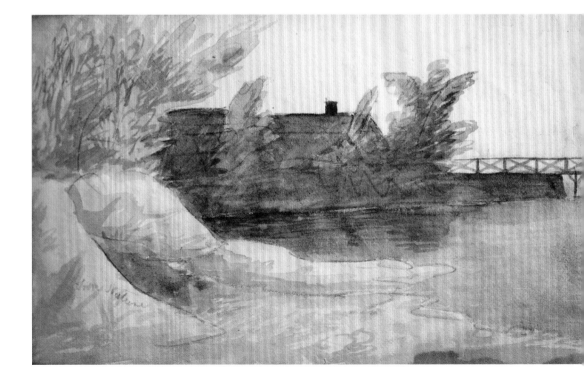

Facing page:
Figure 2-1
1821 Sketchbook
4 ⅜ × 8 inches
Private Collection

Figure 2-2
"Mrs. L. C. Blunt" inscription on label previously adhered to 1821-3

This page:
Figure 2-3
1821-1
Page 1 of 5 additional pages bound with the other three sketchbooks. Blunt's interest in such romantic subject matter as a courting couple was perhaps prompted by his courtship of Esther Peake Colby. The couple were united in marriage later that year.

Figure 2-4
1821-25. Section 2

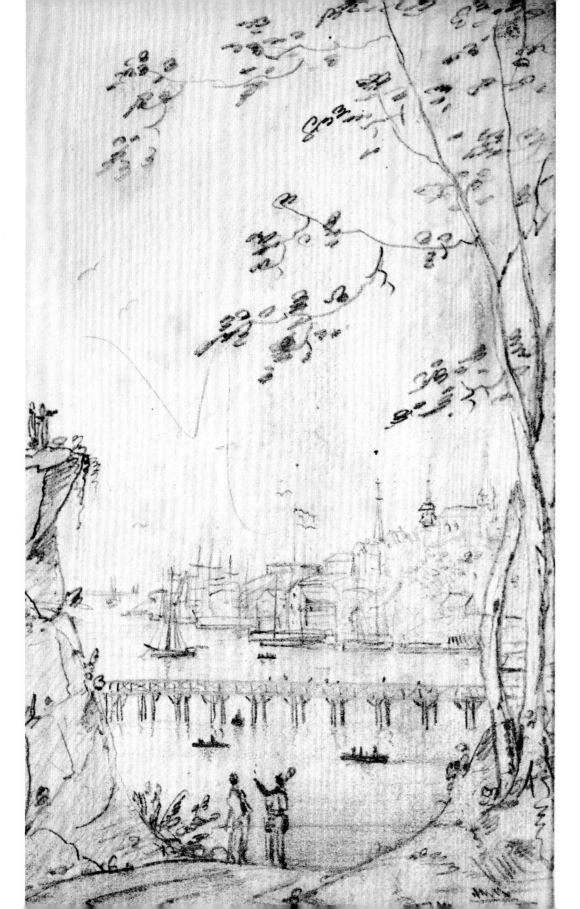

The first five pages appear to be mostly studies for compositions after works by other artists. The second section consists of fourteen pages, with thirteen of the twenty-eight sketches inscribed "From Nature," including three done in watercolor (Figure 2-4). The subject matter is mostly local waterfront scenes freely drawn. One is of John Bowles's windmill on the North Mill Pond in Portsmouth. One drawing of a sailboat with billowing sails near an unidentified shore is dated 1821. This section also includes two tree studies "From Nature;" one is identified as a maple tree and dated 1821 (Figure 1-5).

Section three consists of seventeen pages with much more rudimentary drawings. Nine of them are marked "From Nature," but none are dated. Sketches in this section include some drawn while afloat on water. Subject matter varies greatly, from a study of the Navy Yard shiphouse with Kittery in the distance, two views of bridges, and a rare view of the first lighthouse on White Island, Isles of Shoals, about eight miles off the coast of Portsmouth, New Hampshire. This section also includes a lyrical drawing of a young gentleman shown half-length in a position of repose, as well as a tightly composed drawing of a seaport which appears to be after a print or painting by another hand (Figure 2-5).

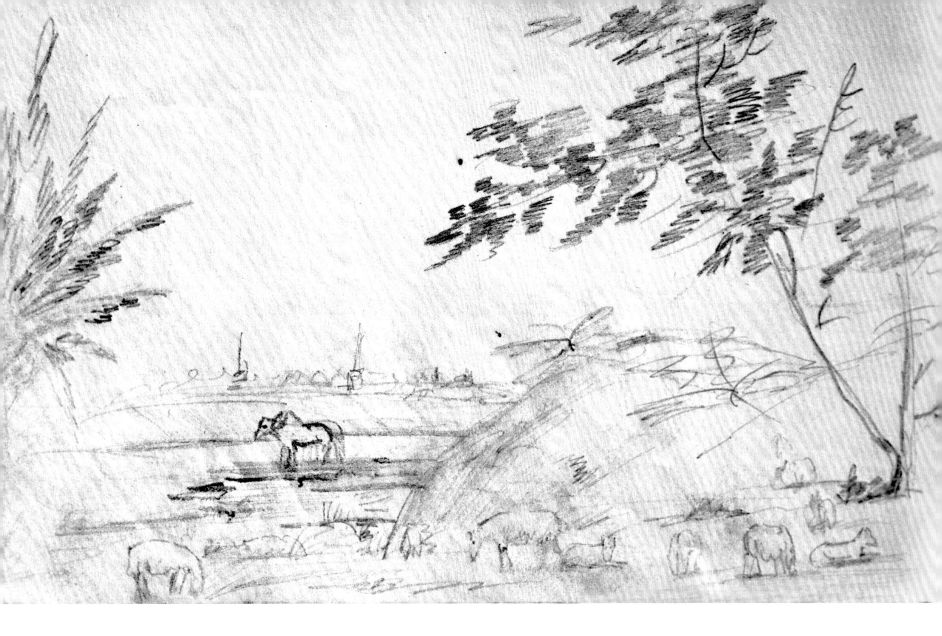

Facing page:
Figure 2-5
1821-45. Section 3

This page:
Figure 2-6
1821-76. Section 4

The fourth section, like the second, consists of fourteen pages. Only two of these sketches are inscribed "From Nature," although other drawings such as this pastoral scene of grazing animals with two church steeples in the distance, appear to be done *plein air* (Figure 2-6). This section also includes a panoramic study taken from the north looking south to southwest across the Piscataqua towards Portsmouth. In this section, he seems to be focusing on themes which demand a good grasp of perspective. He is also traveling through the town of Portsmouth with his sketchbook in hand—capturing the look and feel of the city, on the waterfront and in the shops.

Leavenworth

Inman-Santa Fe
Trail

Kansas City - Mo. South
to Olathe - west to
Council Grove - on west
to Fort Larned - on to
S.W. Fort Inman. So. to Fort
Dodge - west to
Cimarron Crossing
(Arkansas River)
So. West to Trinidad on
to Santa Fe. & to Las Vegas. S.W.
to San Jose w.
Southern Overland
12 miles west of Fort Lyon
Bent's Old Fort

The 1830 Sketchbook

This later sketchbook (Figure 2-9), recently gifted to The Portsmouth Athenæum, passed by descent from the artist's granddaughter Florence to her niece Margaret Linda Jane Blunt (Appendix 2). Born in 1884 in Pueblo, Colorado, Florence was the only daughter of the artist's son Mark Leonardo Blunt, and was quite an adventuresome woman. After language studies at the Sorbonne in France and service in the Women's Overseas League in World War I, she worked in Boston for a brief time before returning to Colorado. After her death in 1964, the sketchbook, an account book of the artist dating from 1826 (the JSB 1826 Account Book) and some early correspondence of her father's were found in a trunk along with another niece's application for the National Society, Daughters of the American Revolution.

Like the earlier sketchbook, this is a fascinating document but for entirely different reasons. Interspersed with the artist's sketches are two pages of directions for the Santa Fe trail (Figures 2-7 and 2-8). On the basis of the place names cited, specifically Fort Dodge, it appears this was a journey that could not have taken place before 1865.[37]

Facing page:
Figures 2-7 and 2-8
1830-20 and 21

Figure 2-9
1830 Sketchbook
8¼ × 6¾ inches
The Portsmouth Athenæum, S0856

This page:
Figure 2-10
1830-26

A second piece of the puzzle concerning ownership of this later sketchbook consists of a five-page listing, written in pencil by another hand, of items from a working farm (Figure 2-10). Further investigation of the purchasers cited indicates many were residents of Guildhall, Vermont. A close perusal of the 1860 census of this area then yielded surprising results. The artist's brother Alfred was cited as a resident farmer there.[38] Perhaps he had moved his family to Vermont at the suggestion of his sister-in-law Charlotte, who was living there at this time with her husband Arnold Adams, a Methodist minister.[39] From these entries it seems likely it was Alfred's belongings that were being sold at auction.

Thus, this later sketchbook passed from Blunt to his widow Esther to his brother Alfred, who had it in his possession by the 1860s. Empty pages in the sketchbook were then used to record sales at his farm in Vermont. In 1866, the directions for the Santa Fe trail were written in the sketchbook to guide Alfred as he traveled west to visit his nephew Mark Leonardo Blunt in Colorado.[40] When Alfred returned to Boston, he could have left the sketchbook behind where Florence found it amongst her parent's household effects and simply added it to her family memorabilia.

This page:
Figure 2-11
1830-1
Detail frontispiece

Facing page:
Figure 2-12
1830-24

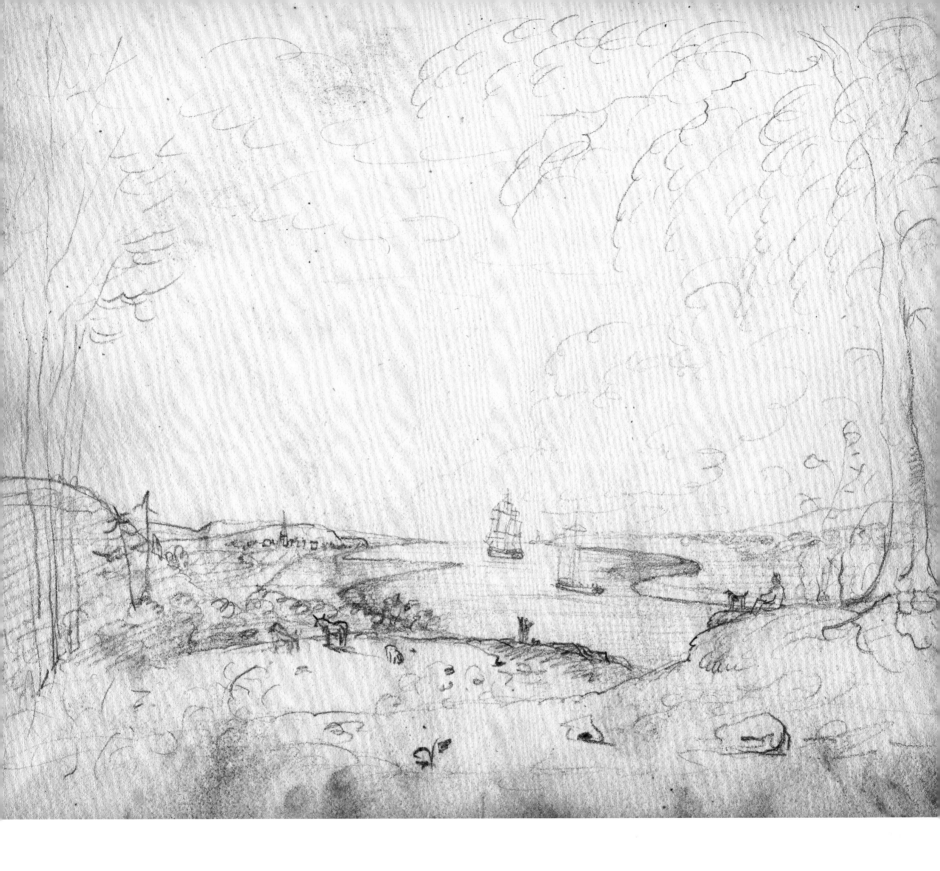

It seems more likely, though, that Alfred had the sketchbook until his death in 1888 in Cambridge, Massachusetts. His daughter Frances Blunt Holt (1849–1934) might have given it to Florence when she was working in Boston in the 1920s.[41] This scenario would also explain how letters written by her father to his mother and siblings in Massachusetts ended up in Florence's possession.

Unlike Blunt's 1821 sketchbook, which was an assembled sketchbook, this one is intact. It consists of thirty-four pages of drawings relating primarily to paintings and prints. A preoccupation with the works of others is apparent from the first page of this book. The frontispiece (Figure 2-11) is a tightly composed vignette by which the artist literally declares his relocation to Boston.[42] This sketch is more in the manner of a draftsman, an illustrator for books and maps, rather than the work of a marine and landscape artist.

Overall, one can see in these later drawings (Figures 2-12 and 2-14) that his technical skills have improved, but the boldness, rhythm and energy of his youth have dissipated. None of them are marked "From Nature." His sublime romantic sketches of nature have given way to more refined and picturesque views. Instead of first-hand study of nature, he appears to be preoccupied with studying the work of others and working on more finished drawings suitable for printing.

Why this transition occurs becomes apparent from the account book he kept. Just as in his earlier ledger book, most of his entries are for ornamental work rather than commissioned portraits or landscapes. Moreover, in 1832 Blunt recorded coloring 610 prints at four cents each for the lithographers Annin & Smith and Company (Figure 2-13).[43] With four children and a wife to support, these were modest wages. Given these circumstances, it is apparent why the focus of his sketches changed. He needed to create art that was more marketable. Instead of coloring prints, perhaps he had ambitions to become a lithographer.

This page:
Figure 2-13
JSB 1826 Account Book, p. 85

Facing page:
Figure 2-14
1830-14
Note how the drawing is squared off in a grid pattern. This would be for enlarging and transferring the composition to canvas or a wall mural such as for his 1830 painted scene for the Daniel Street Theatre (John S. Blunt Account Book. Manuscript Ledger day book 1826–1835, hereafter called the JSB 1826 Account Book. Collection of The Portsmouth Athenæum, S855 p. 42).

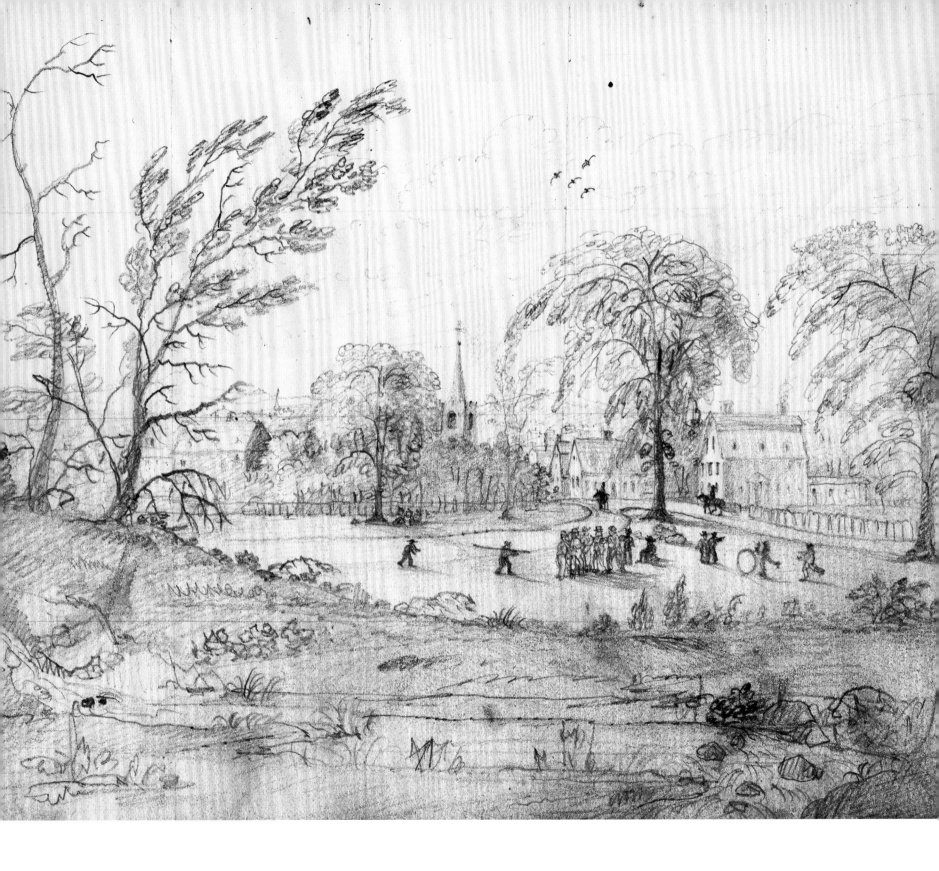

Chapter 3

Real Places. Real Time

*I*n the 1790s, Portsmouth once again became a thriving port for the state of New Hampshire, and a key shipbuilding and furniture-making center. However, with the Embargo Act of 1807, which restricted trade with Britain until 1810, the disruptions of the War of 1812, and another devastating fire in 1813, the city could no longer compete with Boston, the regional entrepôt.

In 1821, fifty-six private wharves, four designated town wharves and a town pier were in operation.[44] The city also began a series of efforts to recapture its market share by upgrading its road system and erecting bridges to facilitate the flow of goods in and out of the city. The largest of these was the Portsmouth Bridge, built in 1822, which spanned the Piscataqua River in order to encourage trade from Maine as well.

Post-fire growth was slow. Building in brick and stone, as specified by the Brick Act of 1814, proved too costly for many.[45] Some elected to erect one-story wooden structures instead. However, a handful of Portsmouth merchants formed development companies with local builders to develop large commercial blocks in brick downtown. They also commissioned elegant homes which they proceeded to furnish lavishly. This attracted artisans from across the state and as far away as Boston.[46]

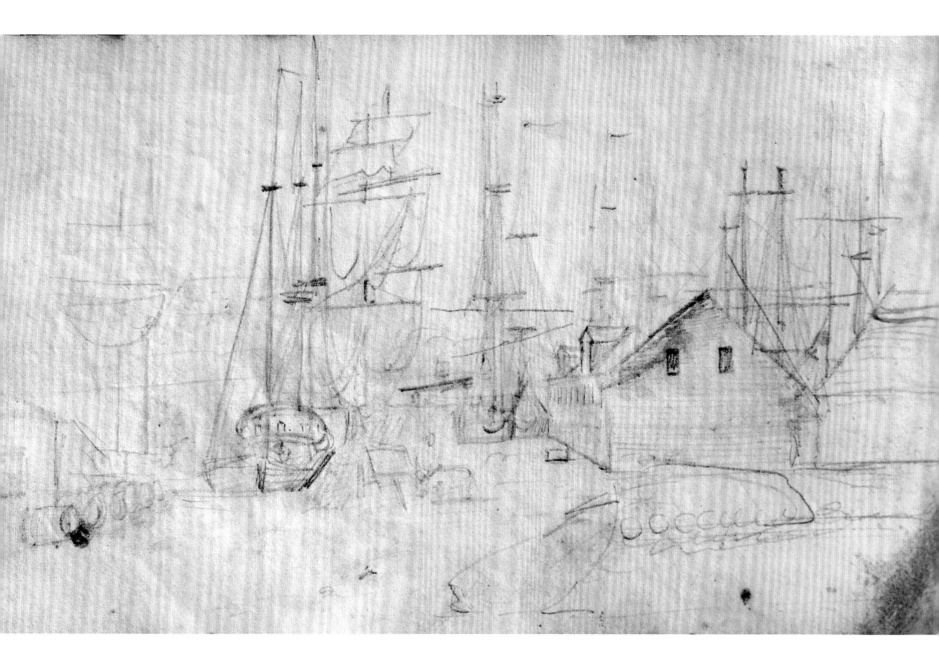

Facing page:
Figure 3-1
Long Wharf, photograph
Strawbery Banke Museum, 805.77

This page:
Figure 3-2
1821- 94

After completing his apprenticeship in the Boston workshop of John Ritto Penniman and a boat trip up the Merrimack,[47] young "Sam" returned to his hometown. He secured a room on Daniel Street just up from Langdon's wharf and nearly opposite the current Post Office. This placed him in the heart of the commercial section of the city.[48] In the 1821 city directory, the first published for Portsmouth, he is listed as "John S. Blunt, ornamental and portrait painter, March's building." His landlord was Nathaniel B. March, a merchant whose primary business was harnesses and saddlery.[49]

As was common practice at this time, especially for those newly established, Blunt placed a series of advertisements in the local papers, the *Oracle* and the *New Hampshire Gazette* (Figure 3-3).

Blunt's point of reference in his advertisement is telling: he describes his room as nearly opposite Mr. Hale's hat store. Thomas Hale was a milliner who opened his shop at Number 5 Daniel Street on May 5, 1821.[50] Trade was sufficiently brisk that the milliner soon outgrew his premises, prompting a move to Market Street later that summer. Blunt's drawing can therefore be firmly dated to between the time Blunt moved into his studio on June 5 and Hale's move on July 28.

In the context of securing customers, Blunt's reference to his close proximity to Hale's shop made good marketing sense. People who could afford to patronize a hat store could afford to patronize the arts. After all, acquiring a new hat or bonnet might prompt having one's portrait done.

Given his proximity to Hale's hat shop, it is not surprising that he made sketches of Hale's premises (Figure 3-4, detail of Figure 3-4 and Figure 3-5). If trade was slow, it is apparent that the clientele at Hale's store could engage his interest. A detail of the sign on the adjacent building with tinware on display confirms that the identification is correct.[51] It is the tin shop of Jonathan Morrison, who is cited in the 1821 directory as a tin-plate worker, with a shop on Daniel Street and a house on Jaffrey Street.

That summer, a second tenant moved into March's premises, printer Samuel Whidden. Other Daniel Street businesses included James F. Shore's bookstore, Charles Pierce's bookstore, Nathaniel S. Pierce's apothecary's shop, and M. & D. Dearing drapery merchants. And just up the street was Sidney Bowen, engraver and copperplate printer, and the *Gazette* office. The artist maintained these same quarters, a few rods south of the Parade, until December 1826, when he relocated to another central downtown location on Pleasant Street at the corner of Court Street.[52]

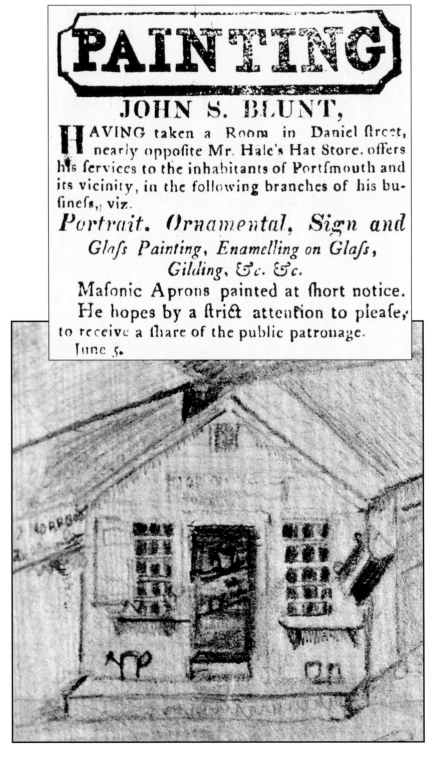

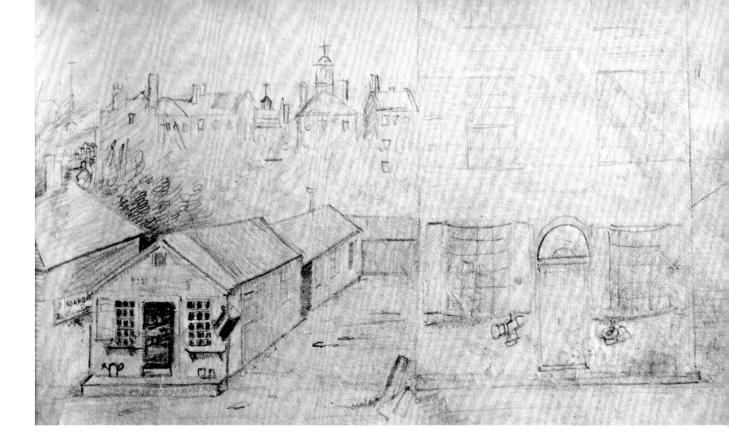

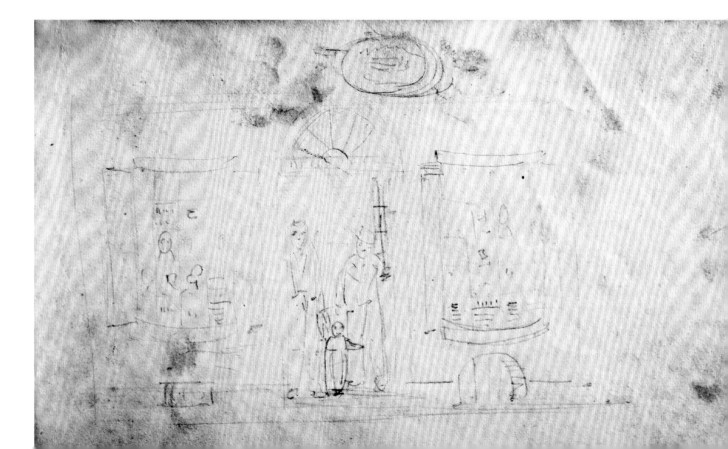

Facing page:
Figure 3-3
New Hampshire Gazette
Tuesday, June 5, 1821,
page 3, column 3

Detail of Figure 3-4

This page:
Figure 3-4
1821-87

Figure 3-5
1821-98

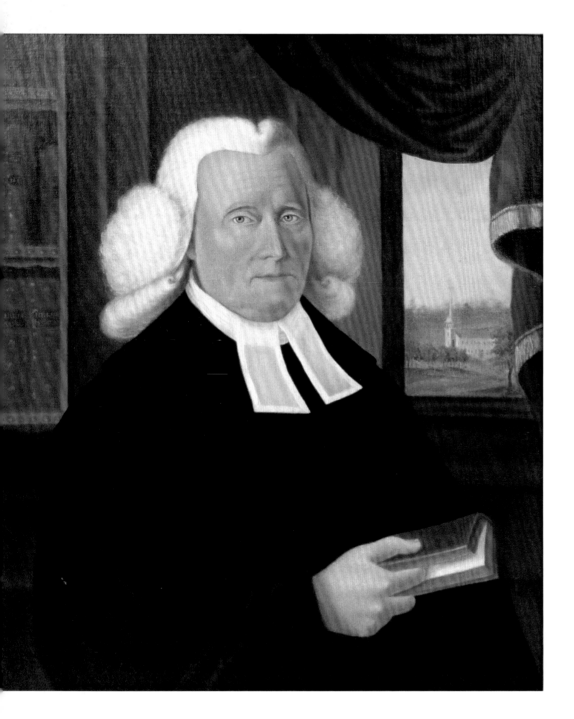

Other Portsmouth places that can be identified in Blunt's sketchbook include the steeple of the meeting house (Figure 3-7) on Meeting House Hill above the South Mill Pond.[53] This steeple was an important landmark and appears in the portrait of South Church minister Samuel Haven (1727–1806) (Figure 3-6). After Blunt purchased residential property on Pleasant Street in 1822,[54] he would pass by it on his way to his painting rooms on Daniel Street.

To the right of the steeple is a head study. The facial features bear an uncanny resemblance to Blunt's classmate at Mr. Taft's school, Samuel Pierse Long (1797–1879) (Figure 3-8). Given their shared interest in the arts, a sketch of Long would not be untoward. After studying law, Long enrolled at the Royal Academy in London and later pursued a career in art education. In Blunt's 1819 Account Book, there is an 1826 entry for mending a prepared canvas for Long.[55]

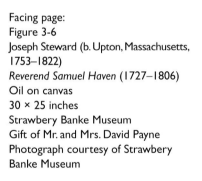

Facing page:
Figure 3-6
Joseph Steward (b. Upton, Massachusetts, 1753–1822)
Reverend Samuel Haven (1727–1806)
Oil on canvas
30 × 25 inches
Strawbery Banke Museum
Gift of Mr. and Mrs. David Payne
Photograph courtesy of Strawbery Banke Museum

This page:
Figure 3-7
1821-39

Figure 3-8
Samuel Pierse Long (b. Portsmouth, New Hampshire, 1797–1879)
Self-portrait
Oil on canvas
27 × 24 inches
Private Collection

Detail of Figure 3-6

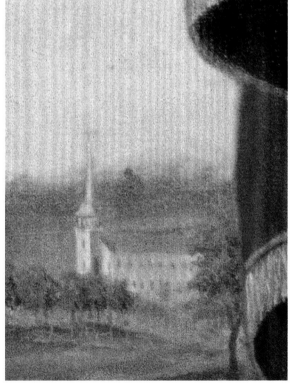

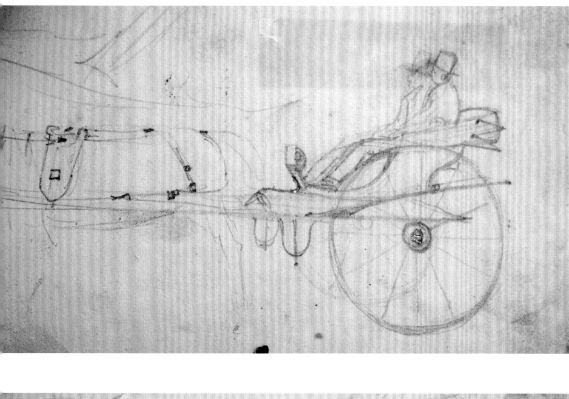

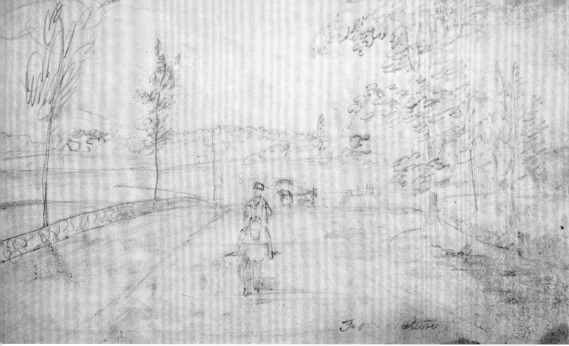

From his sketches, it is apparent that Blunt ventured beyond Portsmouth as well. His drawings of sites along these overland routes are some of the earliest known in northern New England. In the absence of any letters or diaries kept by the artist in 1821, it is not clear if he traveled for work or personal reasons. His fiancée Esther Peake Colby was residing in Boston at that time, but her family kept ties with "Newtown," now Newton, New Hampshire.[56]

Whether he traveled by chaise, like the one he sketched (Figure 3-9) is not known, but his vantage point in the sketch is low enough to suggest he was on foot. The chaise was the first passenger vehicle to be used on New Hampshire highways. "Its rugged construction and two high wheels were well suited for traveling early roads flawed by ruts, stones, holes and stumps."[57] Such a vehicle was also good for traveling over the marshy terrain and heavy clay soil of coastal shores.

A second sketch (Figure 3-10) of a horse and rider with a horse and chaise in the distance could have been drawn on Portsmouth Road. As shown on a detail of Phinehas Merrill's 1806 Greenland map (Figure 3-12), this was the main road leading out of Portsmouth. In Greenland, the road (highlighted in red) forked in two—west across the Portsmouth Plains to Exeter—or south to Boston. From the subjects he sketched, it is apparent that Blunt traveled both routes. Boston was a key destination for him, as it was there he married Esther in October of 1821, the same year he did these sketches.

For Newtown, the road west across Greenland would have been his easiest route. Newtown continued to be a destination for him as late as 1832. In a letter to his wife addressed from Boston and dated August 23, 1832, Blunt states, "I arrived in Boston at 1 o'clock the date after I left Newtown, walking as far as Andover."[58]

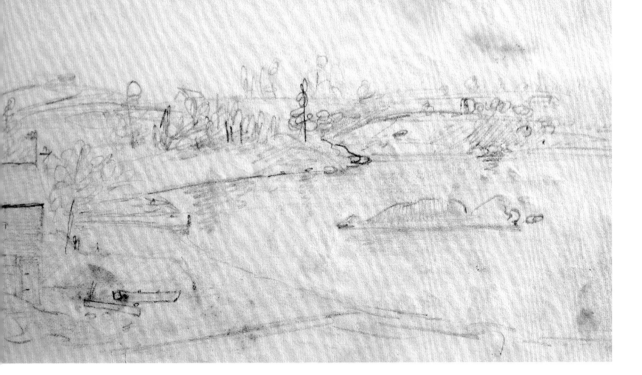

Facing page:
Figure 3-9
1821-3

Figure 3-10
1821-13

This page:
Figure 3-11
1821-83

Figure 3-12
Phinehas Merrill
Detail 1806 Greenland map
New Hampshire State Division of Archives and
Records Management
Image courtesy Gerald H. Miller

Figure 3-13
Tide Mill area and town landing, Greenland
Photograph circa 1900
Courtesy of Paul F. Hughes

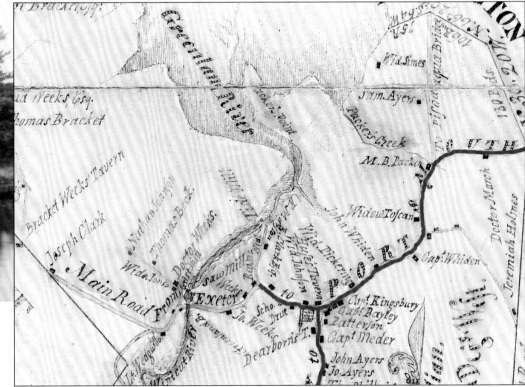

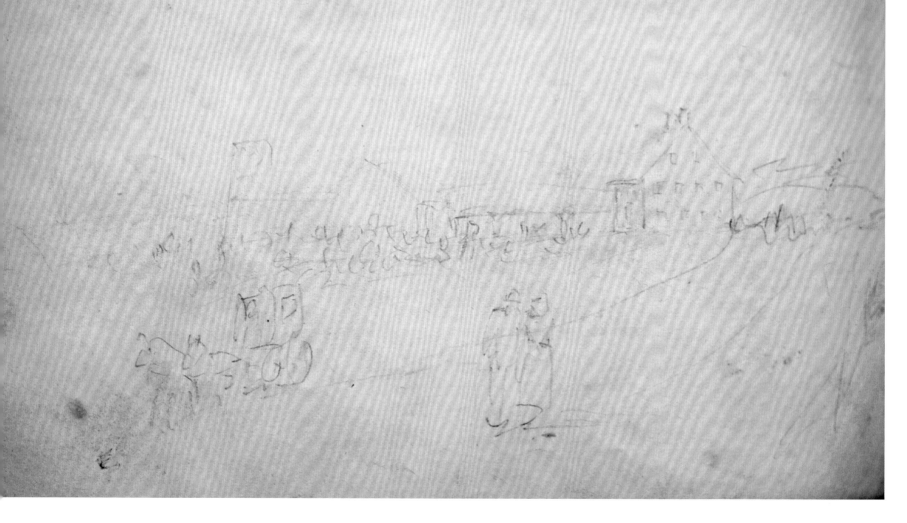

Sites he would have passed on his way west include the Greenland River (Figure 3-11), once the site of a tide mill,[59] and the Globe Tavern, (Figure 3-14), a popular stopping place two miles west of Portsmouth on the Portsmouth Plains. Recall that taverns at this time were more than a place for sustenance, shelter and procuring provisions. They also provided a place for social gatherings, exchanging mail, and news. For an ambitious artist like Blunt, the comings and goings there provided stimulating subject matter.

Continuing overland, the artist paused to paint the Stratham-Newfields drawbridge (Figure 3-16) built in 1775 to span the Squamscott River.[60] From there he turned south to sketch a view of Newfields Landing (Figure 3-18),[61] once an important boatbuilding site. As this route would take him through a region rich in timber, it is possible Blunt might have been traveling to procure lumber.[62] His future father-in-law was a carpenter and housewright in Boston at this time, and might have engaged his services in this capacity.

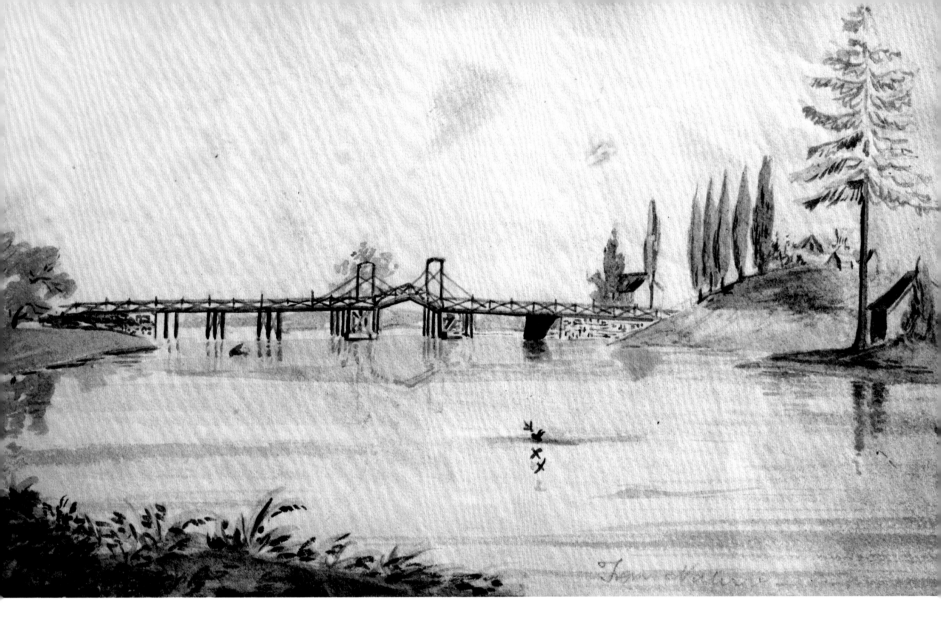

Facing page:
Figure 3-14
1821-96

Figure 3-15
Globe Tavern
Photograph, circa 1900
Walley Museum, St. John's Masonic Lodge, Portsmouth New Hampshire

This page:
Figure 3-16
1821-65
"From Nature"
Stratham-Newfields Drawbridge
Built in 1775 to span the Squamscott River, it provided easy passage for travelers between Newmarket and Exeter.

Although Blunt marks his sketches "From Nature," he makes no reference to any actual locations. Between Greenland and Newtown, distant views of small hamlets like this sketch (Figure 3-19) could be glimpsed along the way.

From his 1821 sketchbook, it is apparent that the artist knew a second overland route: the Winacunnet Road which passes through Greenland, south on Stage Road to Hampton then south into Boston.

On that route, he would have passed North Hill Meetinghouse (Figure 3-23). His choice of an oblique view of this structure might have been influenced by his teacher Penniman (Figure 3-22), with whom he apprenticed as a teenager.

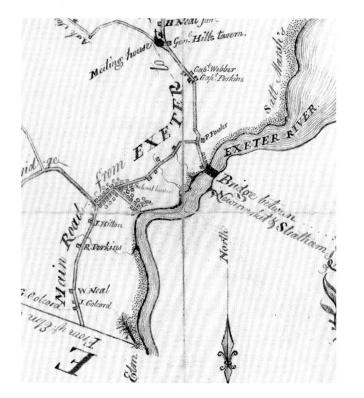

From there, if he continued south along Stage Road, he would have arrived at Josiah Dearborn's Inn (Figure 3-24) in Hampton, New Hampshire.[63] Built in 1816, it stood at the corner of Winacunnet Road and Lafayette Road. From Blunt's 1821 sketch, it is apparent that the Inn was already a major stagecoach stop on the way to Boston.

Close comparison of his sketches with two of his paintings reveals his working methodology. In the first example, the artist combined his pen and ink study of Boston from the southeast (Figure 3-26), his sketch of John Bowles windmill on North Mill Pond (Figure 3-27)[64] "From Nature," and what he learned from his tree studies to create his 1822 painting of *Harbor Scene*, possibly Boston (Figure 3-28). By combining these elements, he created a more dramatic and timeless scene which harkens back to seventeenth-century Dutch masters.

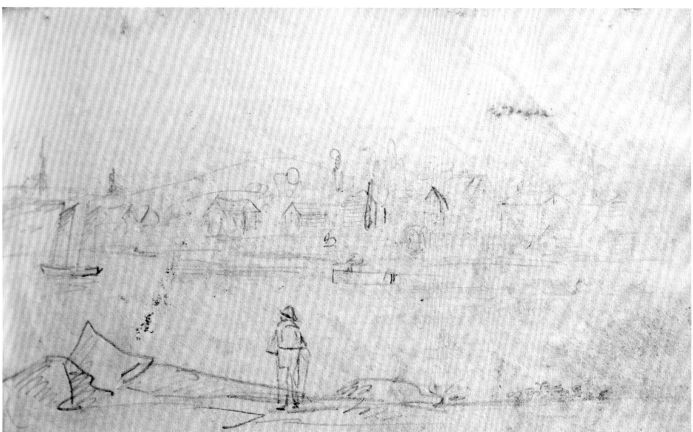

Facing page:
Figure 3-17
D. Smith
Detail 1805 survey of Newmarket
New Hampshire State Division of Archives & Records Management
Image courtesy Gerald H. Miller

Figure 3-18
1821-85
Newfields Landing
Similar waterfront development could be found among many of the small settlements along the Great Bay such as Durham and Newmarket, as well as across the Piscataqua River in Eliot, Maine.

This page:
Figure 3-19
1821-27
Possible view of Simon Wiggin Homestead, Stratham, New Hampshire. This coastal farm was located on the tidal Squamscott River, within an easy walk of the Stratham-Newfields Drawbridge. Now known as the Stuart farm, it is being considered for the National Register of Historic Places.

As was his practice, undoubtedly Blunt did a number of preliminary sketches for one of his most lyrical paintings, North Mill Pond, Portsmouth, New Hampshire (Figure 3-29). These have yet to surface.[65] However, from his sketch of Newfields Landing (Figure 3-18), it is obvious he had studied similar waterfront settlements. Once again, he manipulated elements of the landscape to more dramatic effect. This time he silhouetted a decomposing hull of a ship against a body of water bathed in a setting sun. In keeping with the picturesque tradition, he animated his landscape by giving prominence to the figures in the foreground. One can sense the life lessons these children are embracing as they listen to this elder's saga of yet another ship that has served its time at sea.

Figure 3-20
1821-60
This sketch is a good example of how Blunt occasionally reworked his drawings. Here he simply drew over his sketch of a church spire and proceeded to capture a view of a distant hamlet. His goal was not to make a finished drawing but commit to memory a view that might be suitable subject matter for a future painting.

Figure 3-21
J. Fogg
Detail 1806 Survey of Town of North Hampton, New Hampshire
New Hampshire State Division of Archives and Records Management
Image courtesy Gerald H. Miller

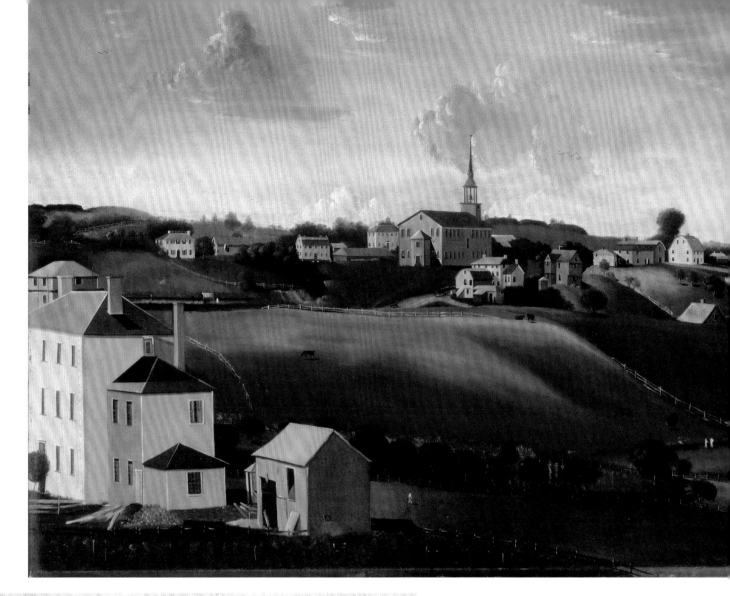

Figure 3-22
John Ritto Penniman (b. Milford, Massachusetts
c. 1782–1841)
Meetinghouse Hill, Roxbury, Massachusetts. 1799
Oil on canvas
29 × 37 inches
Major Acquisitions Centennial and Centennial
Year Acquisition funds, 1979.1461,
The Art Institute of Chicago
Photo © The Art Institute of Chicago

Figure 3-23
1821-95
North Hill Meetinghouse, North Hampton,
New Hampshire, no longer extant.

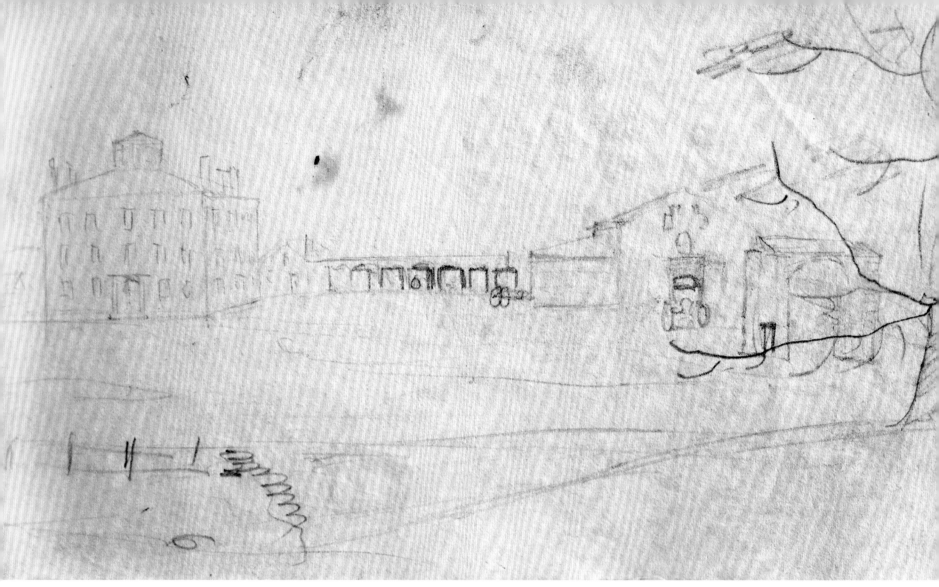

This page:
Figure 3-24
1821-48
Dearborn Inn
By 1821, this building, built in 1816 by Josiah Dearborn (1783–1866), was already a popular coach stop on the way to Boston.

Figure 3-25
Hotel Whittier, Hampton, New Hampshire
Photograph, circa 1890
Courtesy Hampton Historical Society, Hampton, New Hampshire
A public house had been kept continuously at this site from about 1713 when Jonathan Leavitt opened his tavern until the Hotel Whittier burned to the ground in 1916.

Facing page:
Figure 3-26
1821-90

Figure 3-27
1821-36

Figure 3-28
John Samuel Blunt
Harbor Scene, possibly Boston
Signed and dated "J. S. Blunt, 1822"
Oil on panel
15 × 22 inches
Private collection
Photograph courtesy of owner

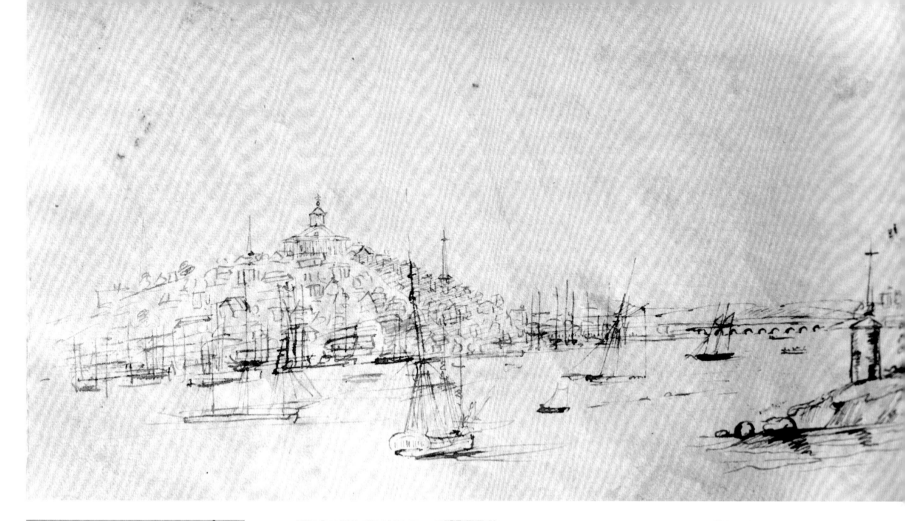

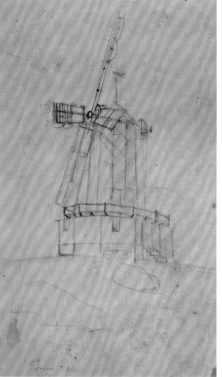

As Blunt matured, he became less of a topographical artist presenting detailed realistic views as he observed them. Instead, the views he sketched became key elements or building blocks which he then manipulated to invest his paintings with meaning. The result is a more poetic and idealistic view of nature that is timeless.

Figure 3-29
Attributed to John Samuel Blunt
North Mill Pond, Portsmouth, New Hampshire, circa 1822
Oil on canvas
19½ × 23¾ inches
Private collection

Chapter 4
Up and Down the Piscataqua

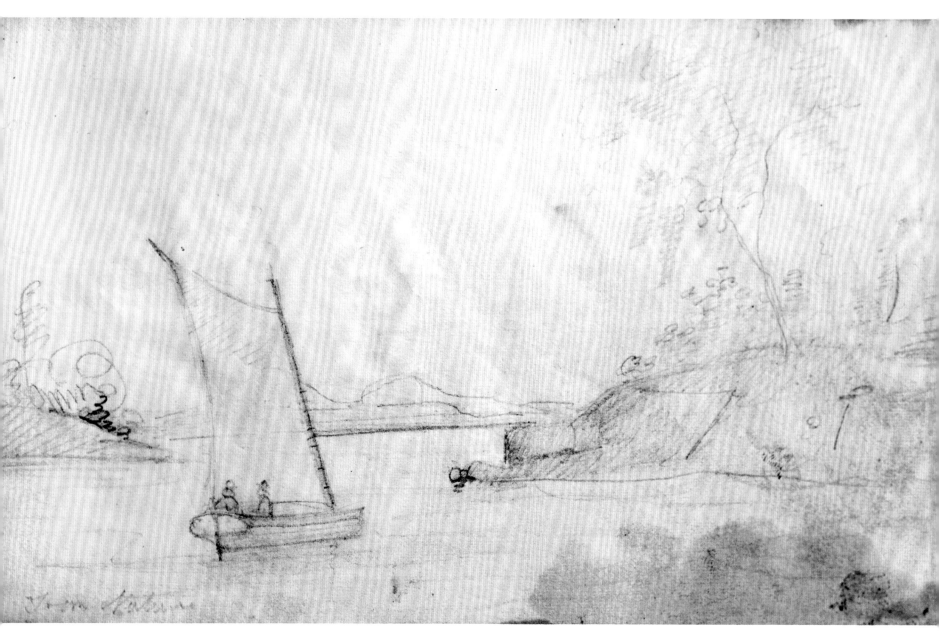

Figure 4-1
1821-21
"From Nature"

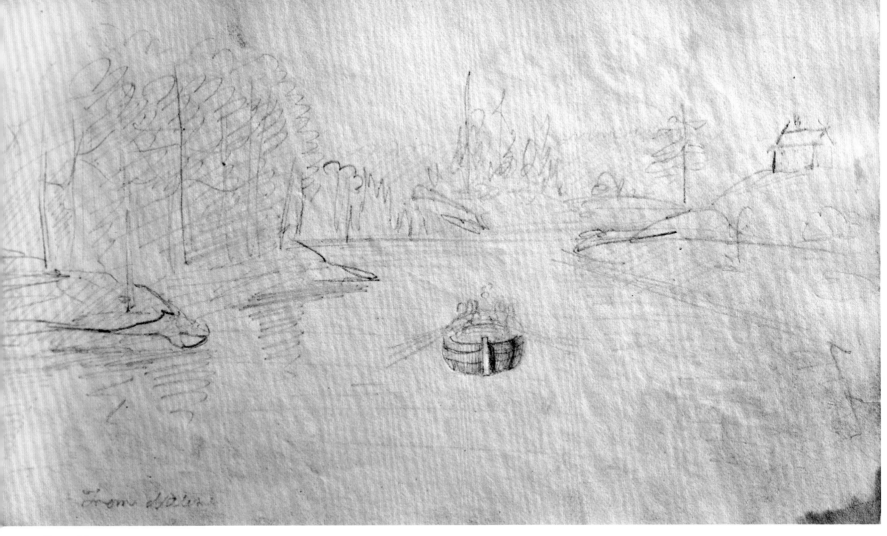

Figure 4-2
1821-55
"From Nature"

Of the hundred drawings in Blunt's 1821 sketchbook, more than half were sketched from the water—shore scenes showing wharves, boats, fish houses, shiphouses, inlets and bridges. As he explored the Piscataqua and its inland waterways, he vividly captured life here in the 1820s. Water vessels of all types—rowboats, skiffs, schooners—were of particular interest. This was clearly subject matter in which he reveled. Curiously, he seems to have made no sketches of gundalows generally declared "the workhorse of the Piscataqua" and unique to the region.

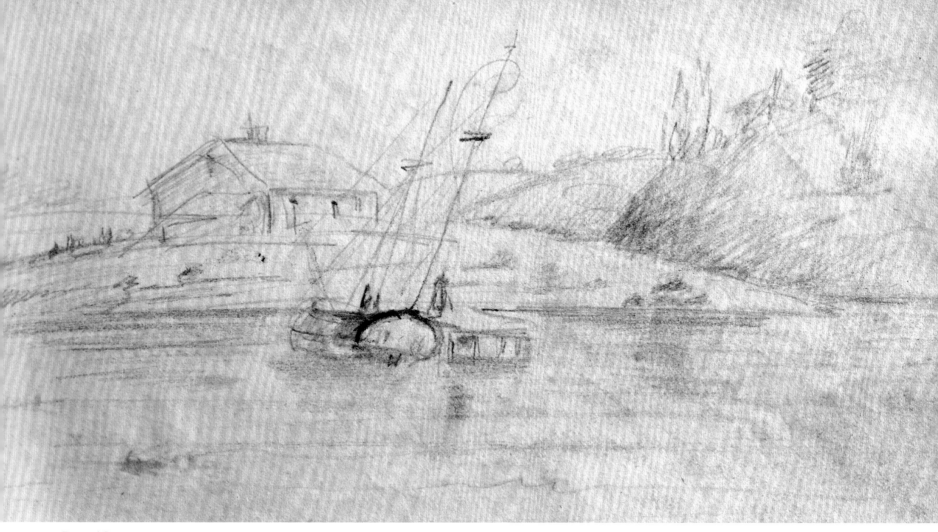

Figure 4-3
1821-89

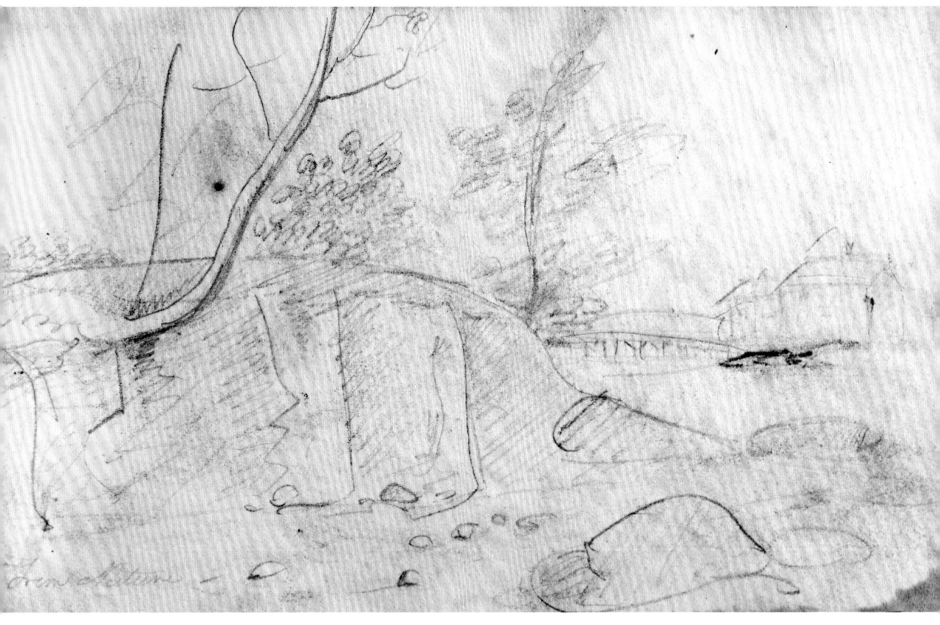

Figure 4-4
1821-37
"From Nature"

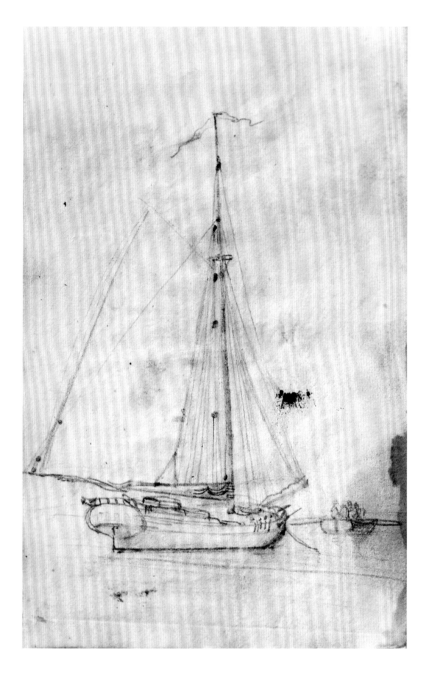

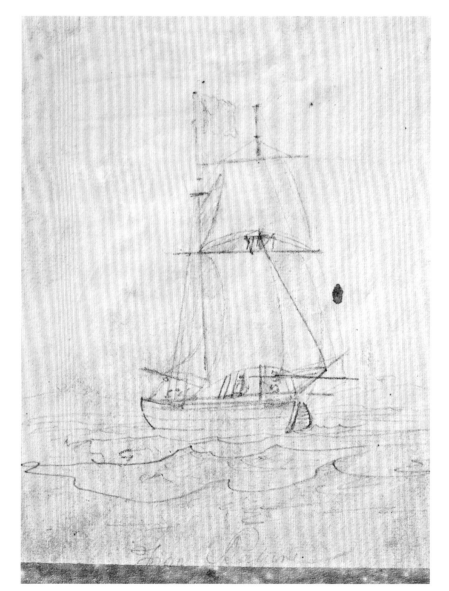

Figure 4-5
1821-24

Figure 4-6
1821-61
"From Nature"

This page:
Figure 4-7
Attributed to John Samuel Blunt
Ship Washington
Oil on canvas
36 × 45 ½ inches
Historical Society of Old Newbury,
Newburyport, Massachusetts
Gift of Rufus Wills

Figure 4-8
1821-62

Facing page:
Figure 4-9
1821-42
White Island, Isles of Shoals
This is a rare view of the first lighthouse built in 1820.

Figure 4-10
1821-40
Gosport Village, Star Island, Isles of Shoals
The steeple of Gosport Church is visible in the distance.

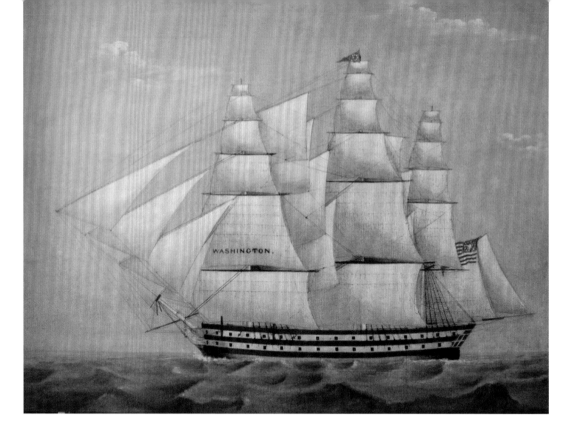

Accurate ship portraits were apparently an early specialty of his. Two large ones of the *Washington* (Figure 4-7) and *Constitution* were once the property of Captain John Wills, a shipmaster, boatbuilder and merchant from Newburyport, Massachusetts. During the War of 1812, Wills and his brig *Leader* were captured by the British while on a voyage from Boston to Bordeaux.[66] Commissioning paintings of two flagships of the United States Navy undoubtedly gave him much satisfaction. Other ship portraits cited in the JSB 1826 Account Book include the *Sarah Parker* (illustrated on page 120), now in the collection of Strawbery Banke Museum, Portsmouth.[67]

As his sketchbook includes views of the Isles of Shoals (Figures 4-9 and 4-10), about eight miles off the Portsmouth coast, it is apparent he was at ease traveling on the water and curious to witness first hand the newly-constructed lighthouse.[68]

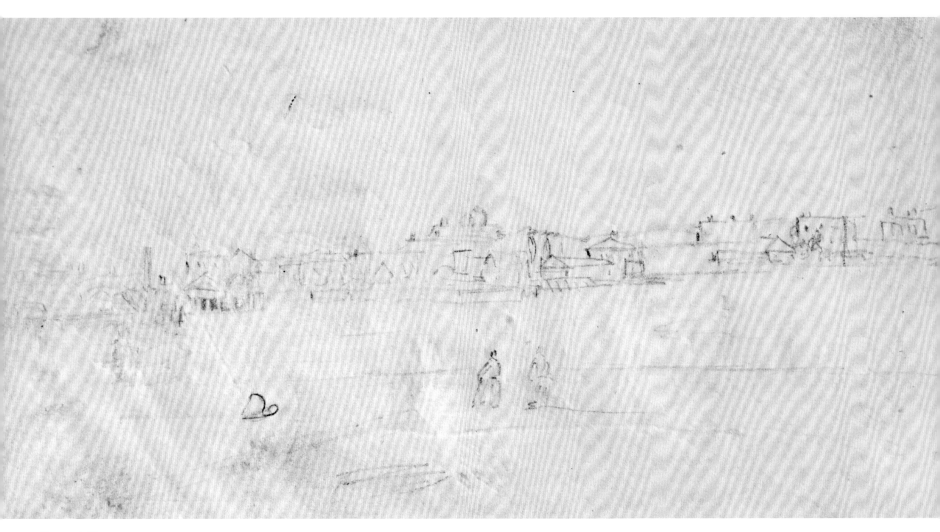

Figure 4-11
1821-30 and 1821-31

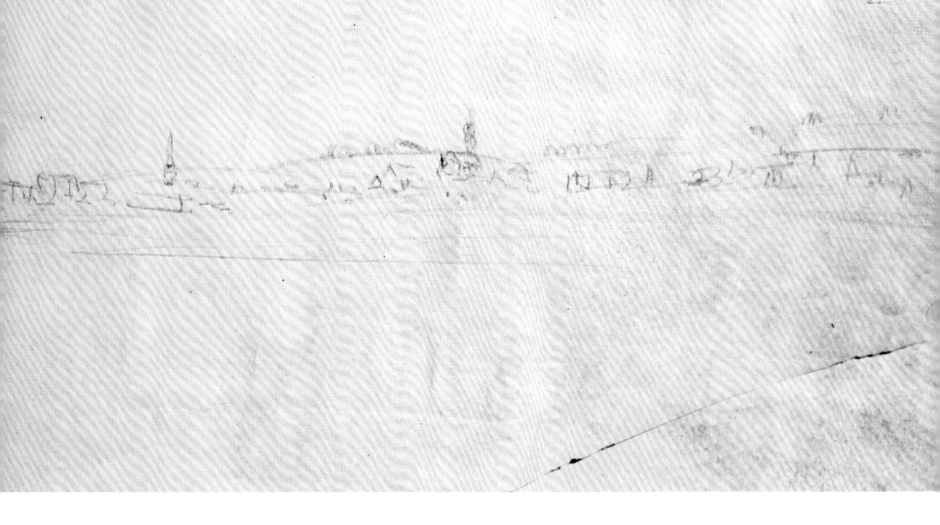

Other views he sketched include a panoramic view taken from the vantage point of Gerrish Island, Kittery, Maine (Figure 4-11). The landmarks can be identified by close comparison of the relation of the structures sketched with Phinehas Merrill's 1806 map (Figure 4-12). On the left is the lighthouse and Fort Constitution of New Castle, and on the right, Fort McClary and Kittery Point Meetinghouse.[69] Two sketches of Fort Constitution are included in this sketchbook, one of the lighthouse (Figure 4-14) before it was reduced in height in the early 1850s,[70] and a second of the barracks with the portcullis gate shown on the left (Figure 4-15).

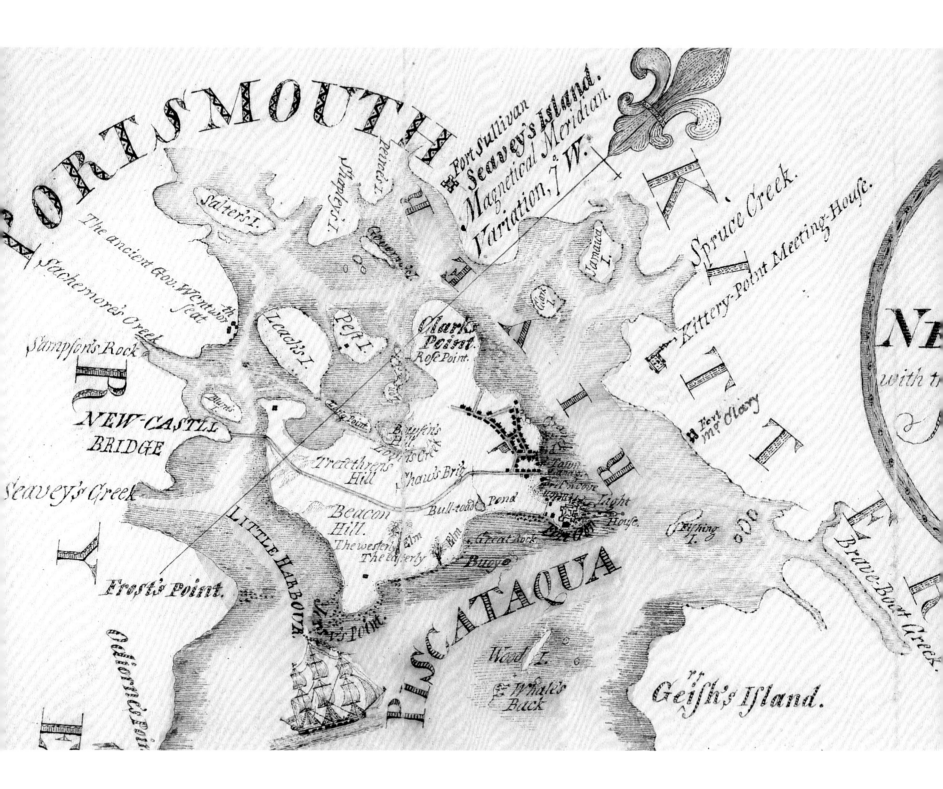

PORTSMOUTH

Salter's I.

I. Sleepdays

The ancient Gov. Wentworth seat

Sachemore's Creek

Stampson's Rock

Leach's I.

Pest I.

Fort Sullivan
Seavey's Island.
Magnetical Meridian.
Variation, 7 W.

Spruce Creek.

Jamaica I.

Kittery-Point Meeting-House.

KIT

Clark's
Point.
Rose Point.

Clark I.

Fort Mc Clary

NE

with tr

NEW-CASTLL
BRIDGE

Burnt I.

Seavey's Creek

Trefethren's
Hill

Brayson's
Hill
Lovin's Creek

Shaw's Brig

Town
Prison
Light
House.

Bull-toad Pond

Beacon
Hill.

The western Elm

The Easterly

Great Rock

Buoy

Fishing
I.

Frost's Point.

LITTLE HARBOUR

's Point.

PISCATAQUA

Brave-Boat Creek.

Odiorne's Point

Wood I.

Whale's
Back

Geish's Island.

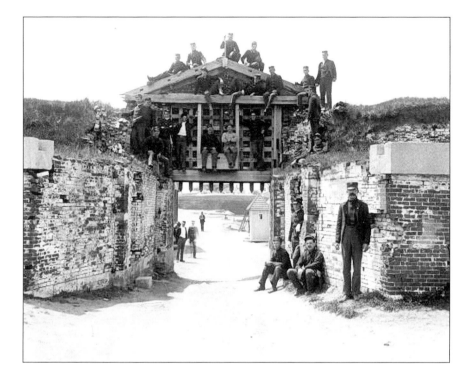

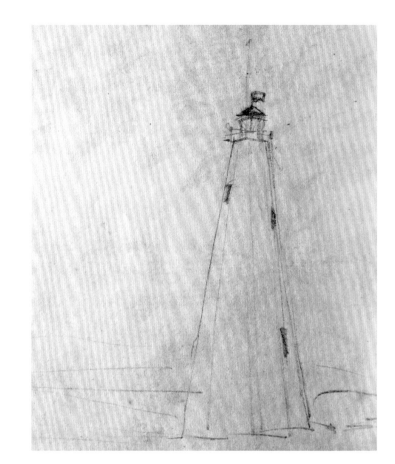

Facing page:
Figure 4-12
Phinehas Merrill
Detail of New Castle map, 1806
New Hampshire State Archives,
Concord, New Hampshire
Image courtesy Gerald H. Miller

This page:
Figure 4-13
Portcullis gate, Fort Constitution.
Photograph, 1902
Strawbery Banke Museum, 374.77
The gate was part of the 1808
walls of the rampart built to
defend Portsmouth harbor.

Figure 4-14
Detail of 1821-78

Figure 4-15
1821-73

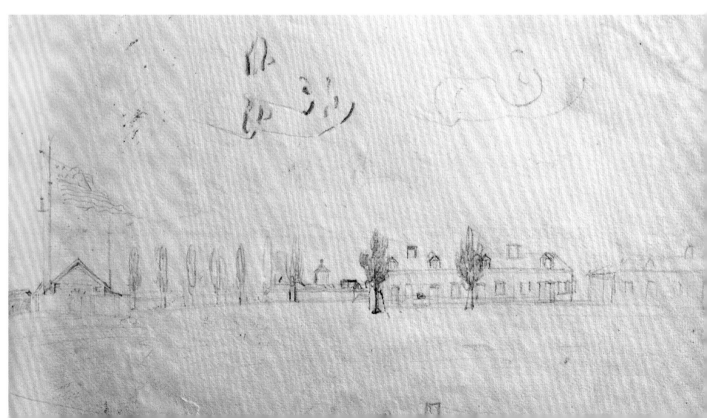

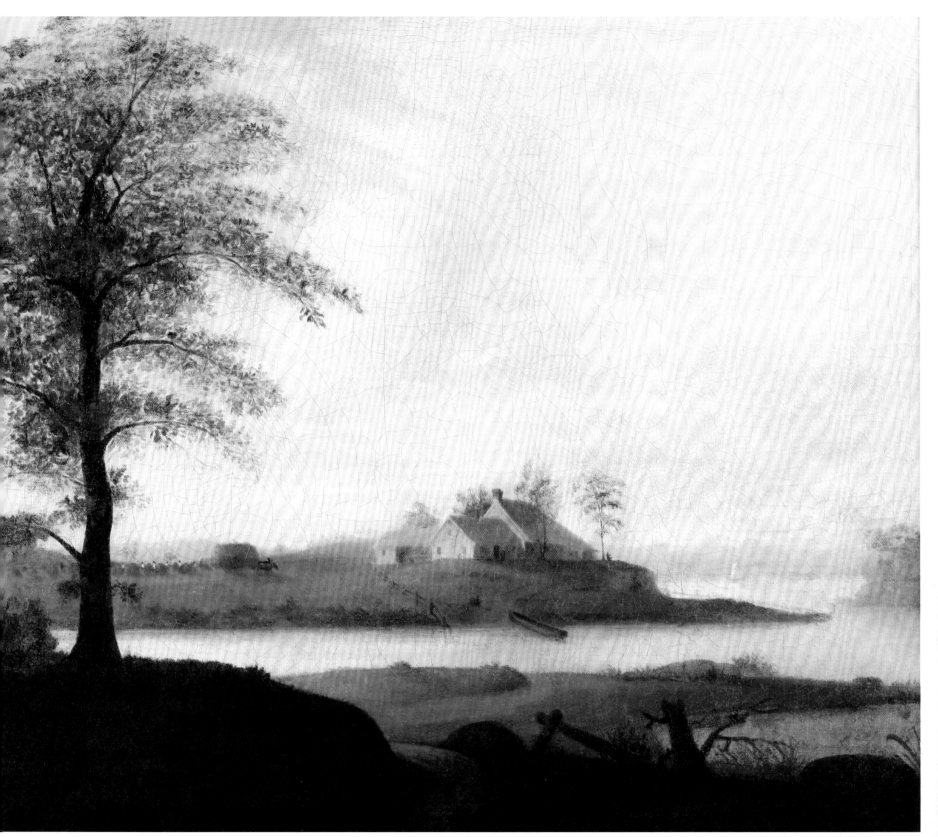

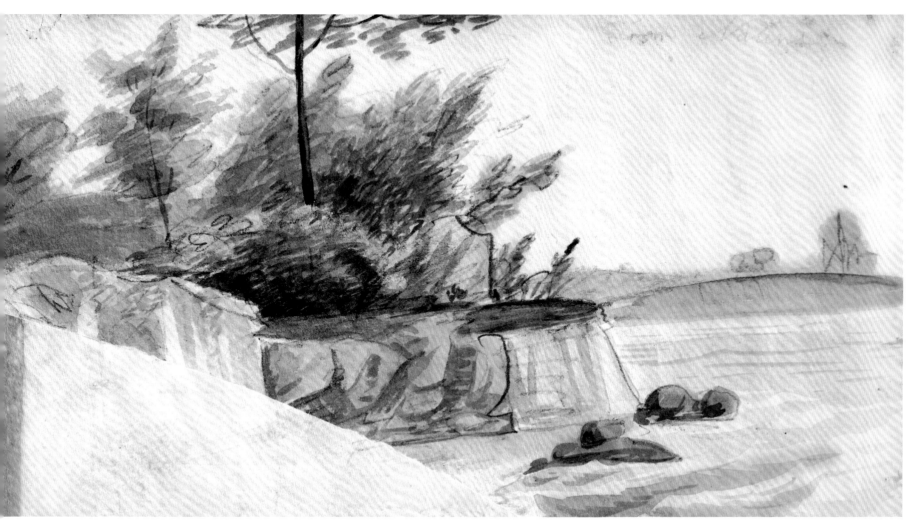

Facing page:
Figure 4-16
John Samuel Blunt
House on a River
Signed and dated lower right on rock "J. S. Blunt 1827"
Oil on mattress ticking
20½ × 24 inches
Inscribed on back "Francis March"
Bernard & S. Dean Levy, Inc., New York, New York
Photograph courtesy of Bernard & S. Dean Levy, Inc
This painting shows what Captain John Blunt's coastal farm may have looked like.

This page:
Figure 4-17
1821-32
"From Nature"

Figure 4-18
View taken from Rye looking across towards Sagamore Creek with Portsmouth in the distance. To the right of the viewer and not shown would be Blunt's Island, now part of the mainland (see Figure 4-12)
2007 Photograph Gerald H. Miller

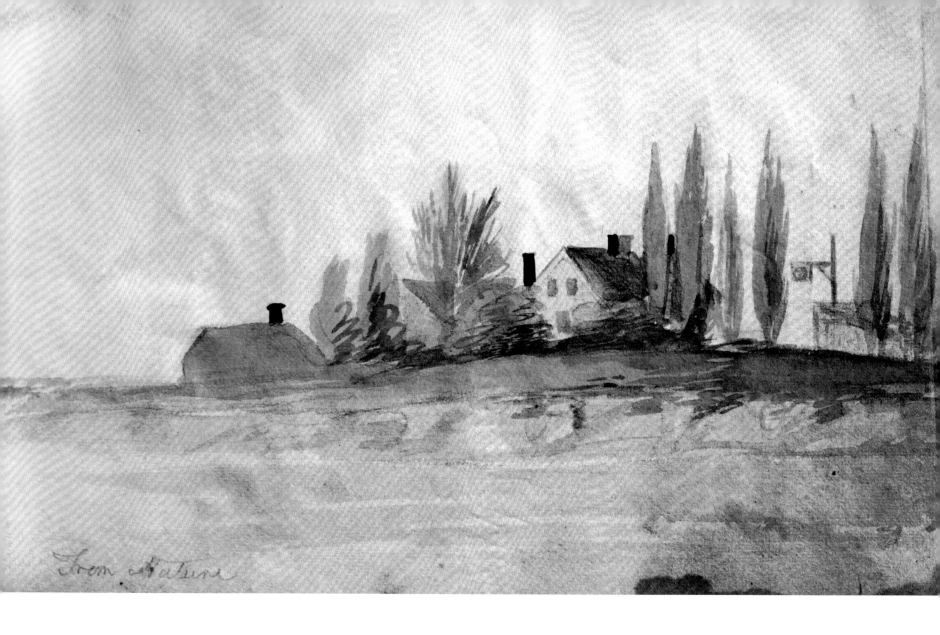

"From Nature"

This page:
Figure 4-19
1821-23
"From Nature"

Facing page:
Figure 4-20
1821-67
"From Nature"

Figure 4-21
View of New Castle Bridge looking across the Piscataqua.
Detail of photograph. Strawbery Banke Museum, 249.77

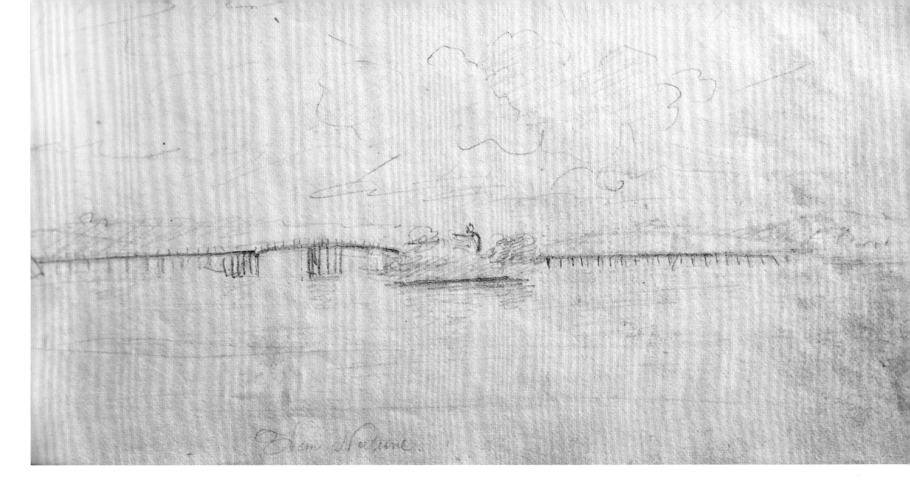

Blunt's desire to sketch in this region might be linked to his family's long association with Blunt's Island. This island in Little Harbor, shown on Merrill's 1806 map, was once the site of his grandfather's home. After his service in Revolutionary wars, Captain John Blunt (1734–1798) maintained a farm there as well as a ferry service from New Castle to Portsmouth.[71] Today the island is joined to the mainland.

A second watercolor study (Figure 4-19) appears to be a view of New Castle taken from the water on Upper Cove. Three houses in a similar configuration are present on the map, but without more information on the actual structures, this cannot be verified.[72] Similarly, a bridge sketch (Figure 4-20) has been the subject of much speculation. It is most likely the bridge from the mainland to New Castle, completed in 1822, on piles with abutments to allow for easy passage of boats. At 2,371 feet in length, it connected Shapley's Island to Amazeen Island to New Castle.[73] If sketched from Blunt's Island, it shows Shapley's Island in the center with a view across the Piscataqua River to Maine.

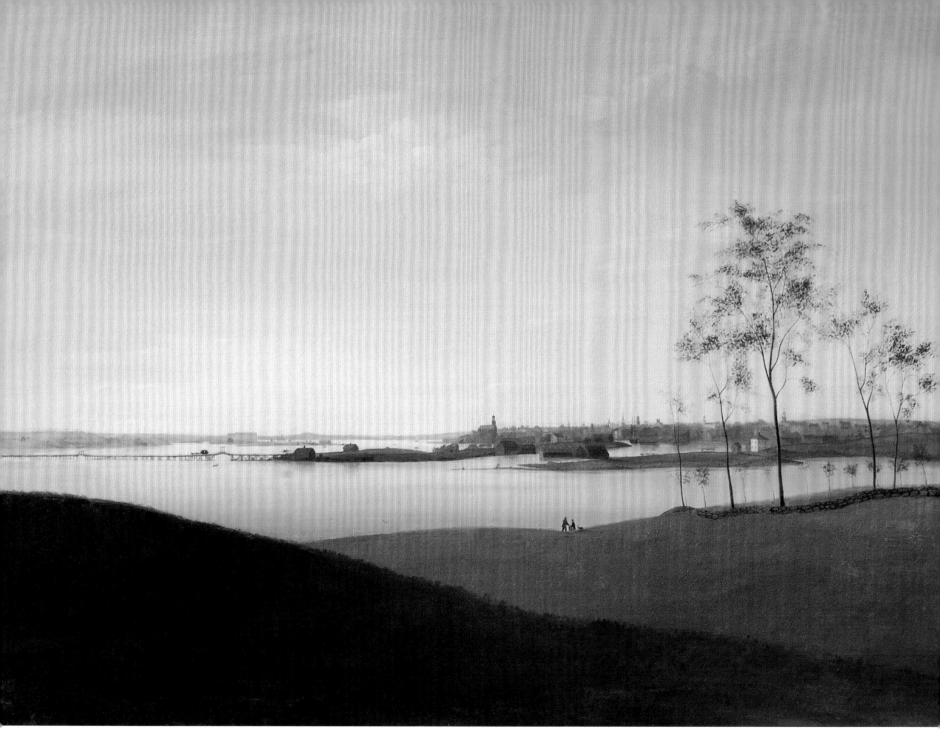

Figure 4-22
John Samuel Blunt
View of Portsmouth, from Freeman's Point, circa 1830
Oil on canvas
45 × 64 inches
City of Portsmouth, New Hampshire
1878 Gift of Colonel William H. Sise, Mayor
Photograph courtesy of Anthony Moore

> "Make sketches from nature of everything and trust not to memory."
> -Alvan Fisher

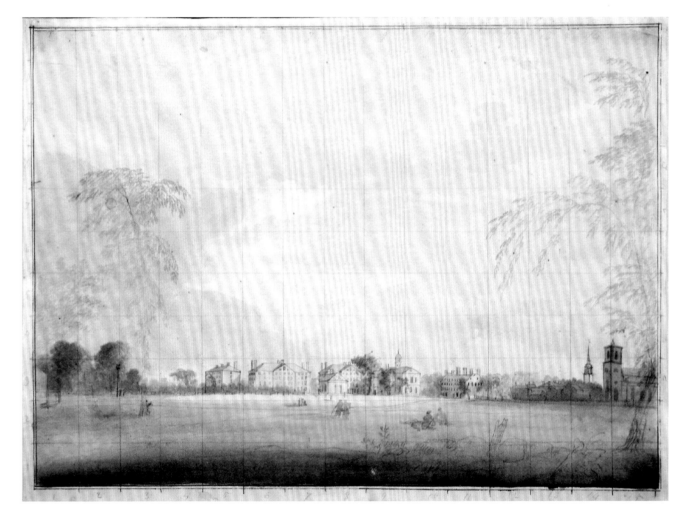

Figure 4-23
Alvan Fisher
Harvard College, Cambridge, Massachusetts, circa 1820
Graphite and ink on paper
9¼ × 12½ inches
Collection of Robert C. Vose III
Photograph courtesy of Robert C. Vose III

Note how the drawing is squared off for translation into a larger format painting.
In this drawing, the low horizon gives the sky and trees prominence, and introduces a
poetical mood to his landscape. Fisher's interest and approach to landscape painting
clearly inspired some of Blunt's most successful paintings.

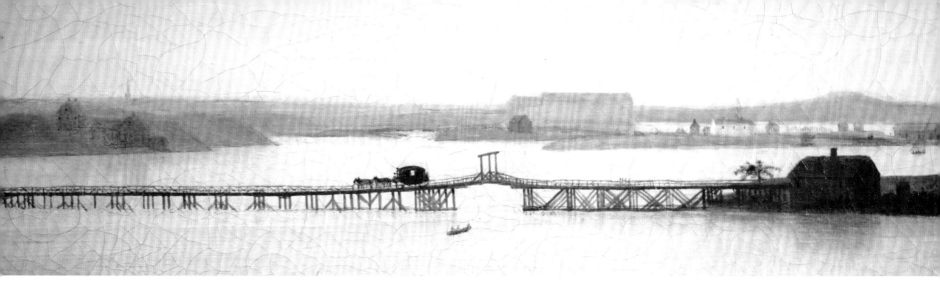

Bridges and panoramic views continued to engage Blunt's interest throughout his career. In his *View of Portsmouth, from Freeman's Point* (Figure 4-22 and details), the Portsmouth Bridge is given prominence. This 1,800 foot wooden-pile bridge was constructed in 1822 and spanned the Piscataqua River, connecting Maine to New Hampshire.[74] Given the monumental size of this work and the care he took to capture all the minute details of the landscape and cityscape, this was undoubtedly a commissioned painting.[75]

As was his practice, Blunt would have filled an entire sketchbook doing preliminary studies for this painting.[76] Although no drawings of this particular composition have been located, Alvan Fisher's drawing of *Harvard College* (Figure 4-23) is a good example of the kind of preparatory drawing Blunt would have executed in preparation for this painting.

That Blunt was able to integrate all the diverse physical elements of his view from Freeman's Point and make a cohesive and convincing view is evident from his 1821 sketches. He never stopped studying the topography of the Piscataqua, its shapes and forms, its panoramic views as well as the effects of atmosphere on the landscape. The effects of a setting sun bathing the landscape infuses this painting with a poetic and highly romantic mood that makes it a masterpiece of the American school of landscape painting.

This page and facing page:
Details of Figure 4-22

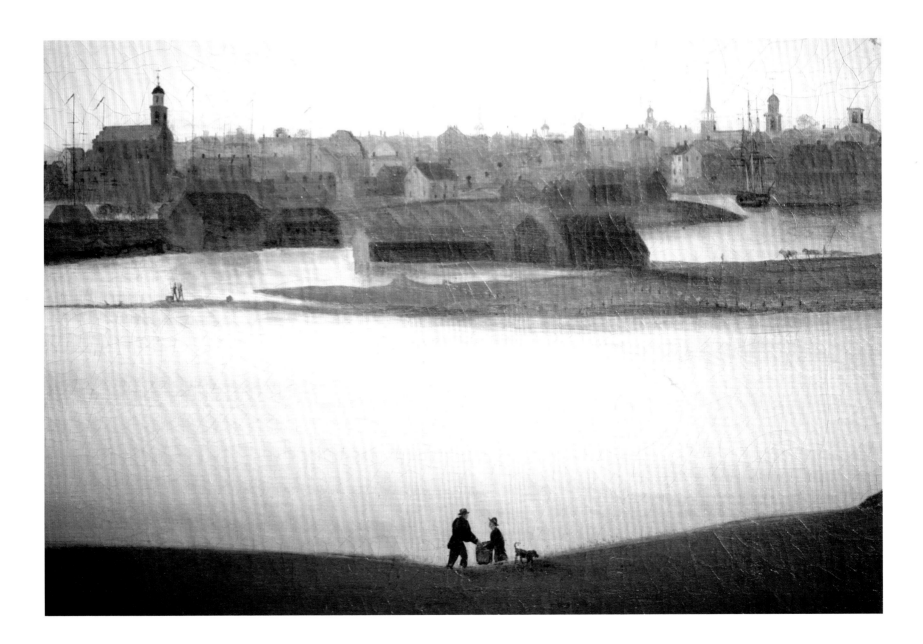

This page:
Figure 4-24
1821-77

Facing page:
Figure 4-25
1821-2

Other sketches made of actual sites have been manipulated by the artist to make pleasing compositions. For example, this sketch (Figure 4-24) looks like a view of Great Bay looking upriver towards Exeter with Mount Pawtuckaway made larger to frame the scene. Another sketch (Figure 4-25) appears to be a view looking up the York River towards Mount Agamenticus.

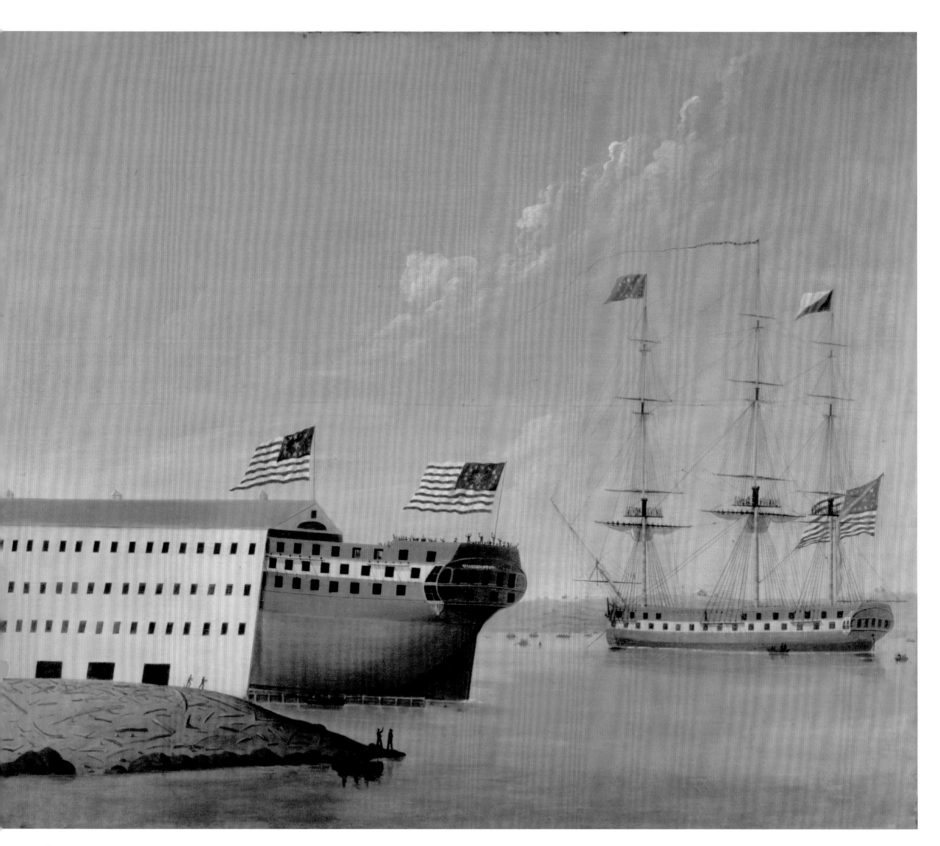

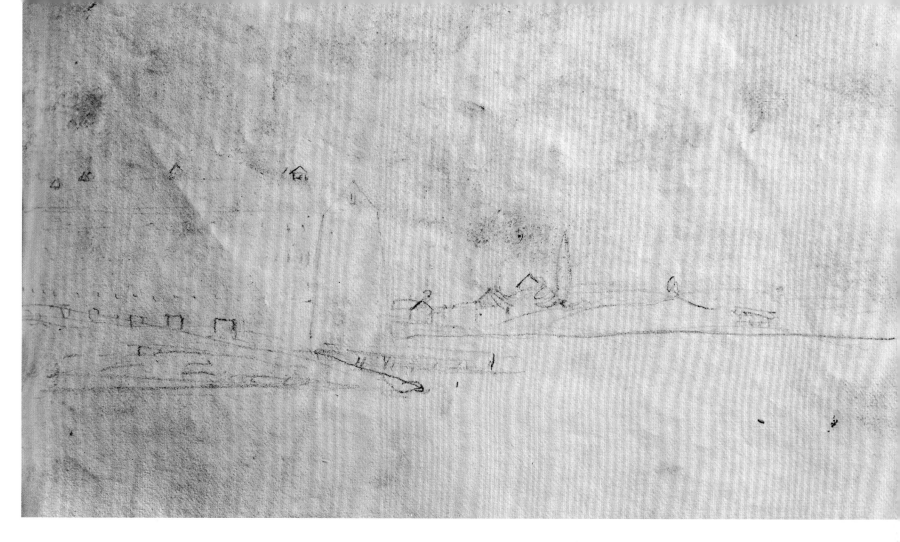

Facing page:
Figure 4-26
Attributed to John Samuel Blunt
Launching of the United States Ship Washington, circa 1815
Oil on canvas
48¼ × 57⅝ inches
Courtesy of Historic New England
Gift of Bertram K. and Nina Fletcher Little
Photograph Peter Harholdt, 2003

This page:
Figure 4-27
1821-58

Local landmarks such as the shipyard continued to engage his interest. This 1821 sketch (Figure 4-27) is one of two studies of the Alabama Shiphouse, Portsmouth Navy Yard, Seavey's Island, Maine. This is the same shiphouse present in *Launching of the United States Ship Washington* (Figure 4-26) of 1815,[77] still the earliest and most ambitious painting identified in his *oeuvre*. It illustrates the actual launching that took place in Portsmouth harbor in 1814. The attribution of this painting to the then sixteen-year-old Blunt was first made by the eminent scholar Nina Fletcher Little. This sketch of the shiphouse confirms her attribution. The artist's drawing of this building is so close in form and approach to the rendering of the shiphouse in the painting, it had to have been done by the same hand.

It also shows how Blunt continued to study and sketch the same views on the Piscataqua throughout his brief career. The structure, built in 1813 by Jonathan Folsom,[78] was lengthened in 1817.[79] The same shiphouse appears in another Blunt painting *View from Noble's Wharf* (Figure 4-30), this time viewed from across the Piscataqua.

A comparison between this painting and a later one is most informative. *Noble's Wharf,* which dates to 1824, is more topographical than his 1828 *United States Ship Constitution* (Figure 4-31). Although both paintings incorporate Piscataqua views, the later painting is far more dramatic and ambitious. The view is from Fort McClary looking out toward the mouth of the Piscataqua River to the open sea. Here, the rocky foreground, the full sails reflected in the tranquil water, and the dramatic clouds under a setting sun focus the viewer's attention on the ship. A ship with full sails in a harbor appears to have been a favorite theme, as he did at least three versions of it.

His inclusion of the Walbach tower and a lighthouse into the land mass on the right is important. During the War of 1812, Fort Constitution was the main defense for protecting the port of Portsmouth. Although there are no known sketches by Blunt of this particular "Martello" defensive tower, named in honor for Colonel Walbach, who did service at the fort, it was a prominent feature on the Piscataqua. Blunt might have even observed it being built during the British blockade of Portsmouth Harbor. To these features, he added the houses and trees he featured in his earlier watercolor study (Figure 4-19).

By incorporating elements of the actual landscape, its historic landmarks, and blending it with a large sailing ship bathed in a setting sun, the painting becomes rich with symbolism and an artistic tribute to American naval history. Not surprisingly, this painting was once the property of the family of Levi Woodbury (1759-1851), a Portsmouth resident and the Secretary of the Navy from 1831 until 1834.[80]

In summary, as the artist matured, he combined elements of what he sketched in nature with the atmospheric effects he observed in order to imbue his paintings with a deeper and more symbolic meaning.

PORTSMOUTH NAVY YARD

This page:
Figure 4-28
View of Portsmouth Navy Yard
Detail of *Township and Rail Road Map of the State of New Hampshire, 1854*
New Hampshire State Division of Archives and Records Management
Image courtesy Gerald H. Miller
Not surprisingly, the Navy Yard continues to be a subject of popular local interest as evidenced by this engraving from a New Hampshire map.

Figure 4-29
Alabama Shiphouse, Portsmouth Navy Yard
Photograph, not dated
Strawbery Banke Museum, 1207.77

Facing page:
Figure 4-30
John Samuel Blunt
View of the Piscataqua River from Noble's Wharf
Signed and dated lower left "J. S. Blunt 1824"
Oil on canvas
26 × 33 inches
The Portsmouth Athenæum
Gift of Joseph and Jean Sawtelle
Photograph Ellen McDermott, 2006

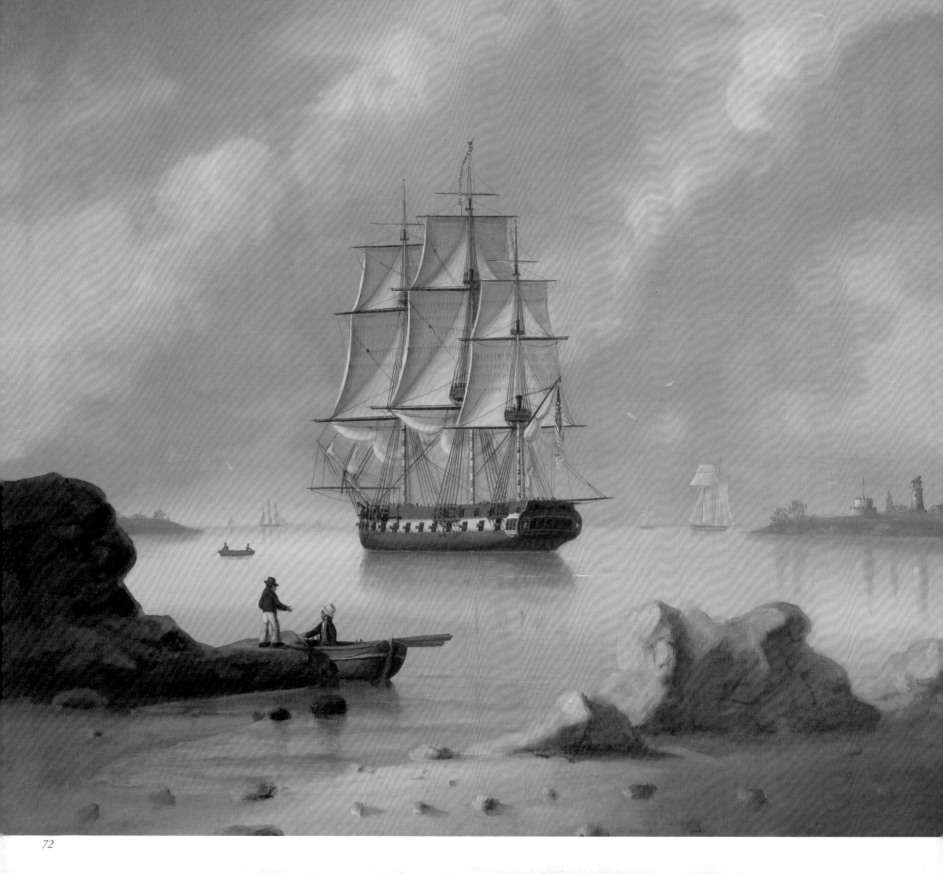

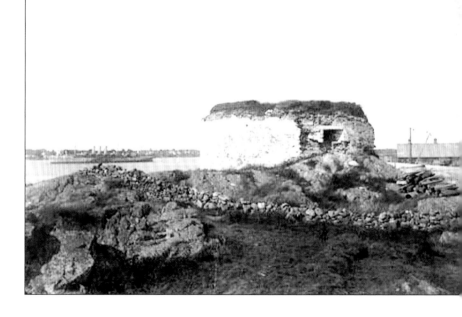

Facing page:
Figure 4-31
John Samuel Blunt
United States Ship Constitution aka Seascape with Ship in Calm Waters aka U.S. Frigate
Signed lower right "J. S. Blunt 1828"
Oil on canvas.
23½ × 27½ inches
Collection of Arthur J. Phelan
Photograph John Woo, Frederick, Maryland

This page:
Figure 4-32
Detail of 1821-99

Figure 4-33
Walbach Tower. Photograph
Strawbery Banke Museum, 703.77

Detail of Figure 4-31

Figure 4-34
Panoramic view of Portsmouth Harbor
Photograph Gerald H. Miller, 2007

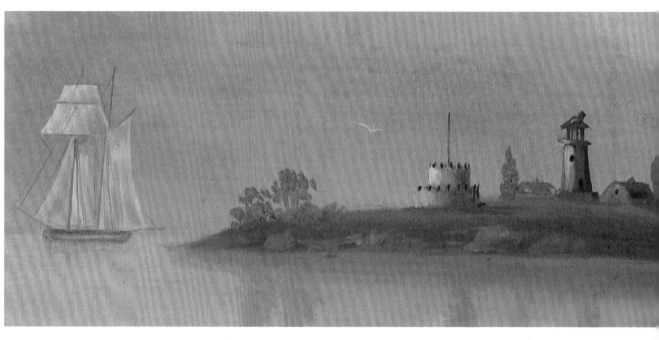

Chapter 5

Figural Studies and Fancy Work

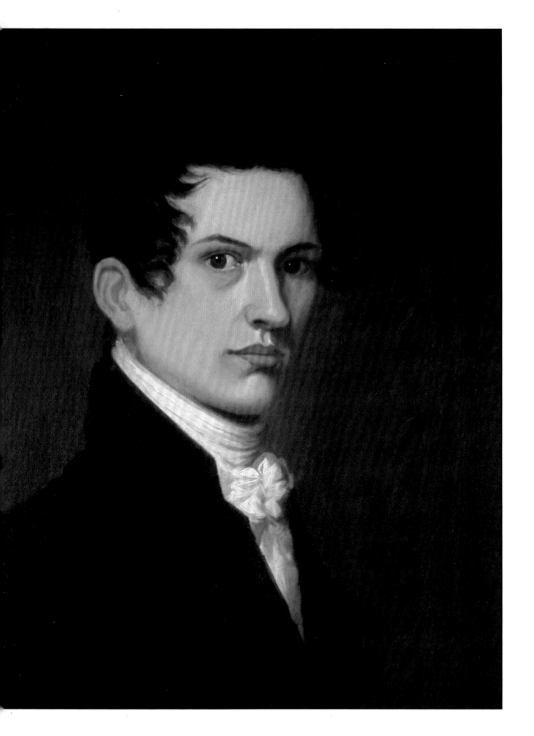

*F*ollowing in the wake of Dr. Bishop's identification of Blunt as the Borden Limner, interest in this artist's portraiture work became intense. As it does not appear this artist signed and dated his portraits, the opportunity to study figural sketches by Blunt is especially valuable. Alas, the sampling is small—only four pages in two sketchbooks concern the human figure.

His most developed figural study (Figure 5-2) shows how well Blunt could capture mood and character with his pencil. There are no notations on the sketch as to the identity of the sitter. Given the artist's sensitivity to his subject, it could be a study of his younger brother Mark. Born in Portsmouth on June 11, 1802, Mark, like his brother John, had been a scholar at Master Taft's. However, nothing more is known about him apart from his early death. On July 25, 1824, he was found drowned in Boston harbor, near Rowe's wharf.[81]

Another candidate for the sitter is the artist's friend and colleague Nathan Negus. Comparing the sketch and Negus' 1820 self-portrait (Figure 5-1) is informative. They have the same features: a long sensitive face, an aquiline nose, pursed lips, a prominent chin and large ears.[82]

The two artists apprenticed together in the Boston workshop of John Ritto Penniman where they learned all the techniques of the decorative trade. Continued contact between the two is confirmed by Negus's diary entry for November 20, 1819 that: "J. Saml. Blunt & Wm. P. Codman return from their country excursions."[83] That Negus called him Samuel rather than John in his diary is also telling, as this was the given name that Blunt's family used for him as well.[84] There are also citations in Negus' diary relating how he and his fellow artists would frequently sketch each other.[85] If Negus is the sitter here, this would impact the dating of the sketchbook. As Negus departed for the southern states in December of 1820, the sketches from this third section of the sketchbook may be earlier than 1821.

Facing page:
Figure 5-1
Nathan Negus (1801-1825)
Self-portrait, circa 1820
Oil on panel
20 × 17 inches
Pocumtuck Valley Memorial Association,
Memorial Hall Museum,
Deerfield, Massachusetts, 1993.21.09

This page:
Figure 5-2
1821-64

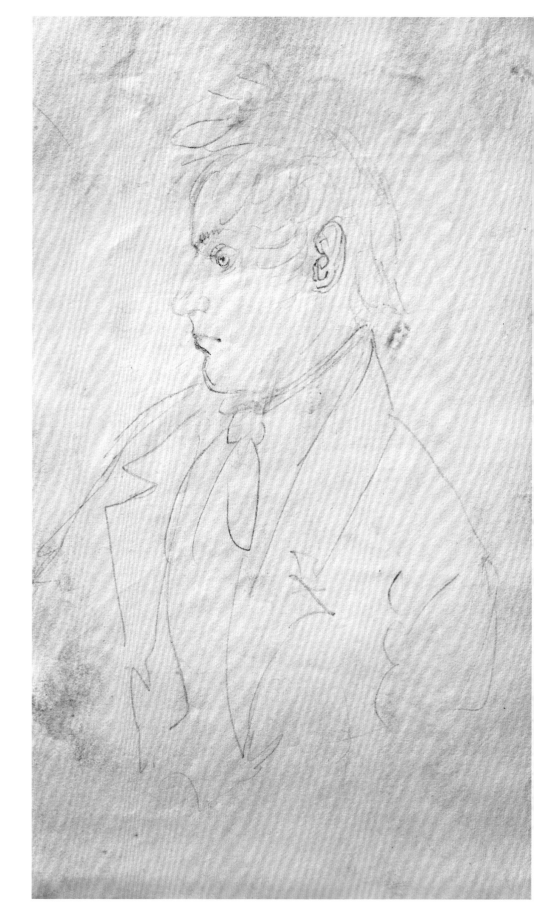

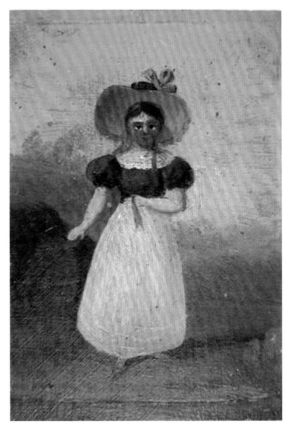

Another page in Blunt's 1821 sketchbook (Figure 5-3) depicts ladies in fancy dress including a bust and shoulder portrait of a girl with a wide-brimmed hat. This is a study for a small painting of a girl shown full-length standing in a landscape (Figure 5-4). She is wearing the same kind of wide-brimmed hat and her gesturing arm has the same wooden articulation as the gesturing figure in his sketch. The panel belongs to another branch of the Blunt family. It is inscribed on the back "Painted by John S. Blunt for Plumy Colby 1821."

Plumy was his wife's younger sister. She was born in 1817 and would have been four years old in 1821.[86] At that time, both sisters were residing on Pleasant Street in Boston with their father Joseph Colby (born Newtown, New Hampshire, 1777–1848), a carpenter and house builder.[87] The marriage between Blunt and Esther took place in Boston, but no other details of the event are known.[88] As both the sketch and the panel are dated 1821, it is possible this sketch was done at the time of their wedding. Such an interpretation would explain the fancy dress of the two ladies—perhaps they were in the wedding party. Could they be studies of Esther's two other sisters, Charlotte, born 1805, and Pamela, born 1806?

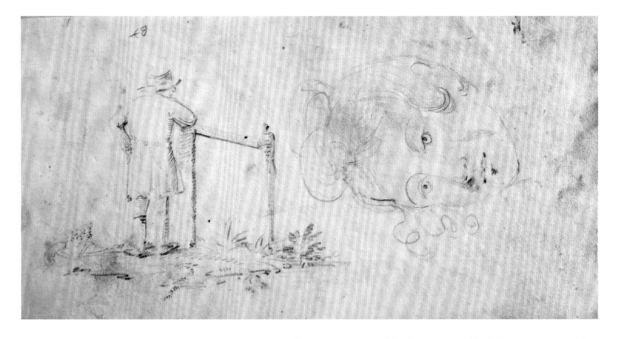

Facing page:
Figure 5-3
1821-26

Figure 5-4
John Samuel Blunt
Little Girl in Red Hat
Inscription on back: "Painted by John S. Blunt
for Plumy Colby 1821"
Oil on panel
6⅞ × 4¼ inches
Courtesy Charles E. Blunt family
Plumy Colby was Esther's younger sister and
later the bride of the artist's brother Alfred,
(Appendix 2).

This page:
Figure 5-5
1821-100

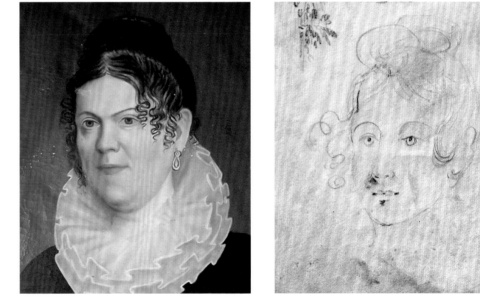

Figure 5-6
Attributed to John Samuel Blunt
Detail of portrait of *Sarah H. Drisco March*
(1780-1844)
Oil on canvas
30 × 24 inches
Private collection
JSB 1821 Account Book: "N. B. March
$12.00 for painting a portrait June 30, 1821"
Nathaniel B. March was Sarah's spouse.

Detail of Figure 5-5

Figure 5-7
Label on back of portrait (Figure 5-6)
Old ink inscription reads: "Portrait of
Mrs. Sarah H. March/ of Portsmouth, New
Hampshire/ June 18 [not legible] when she
was [not legible] years of age/ [initials] H.P."

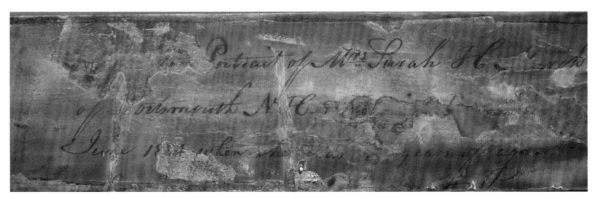

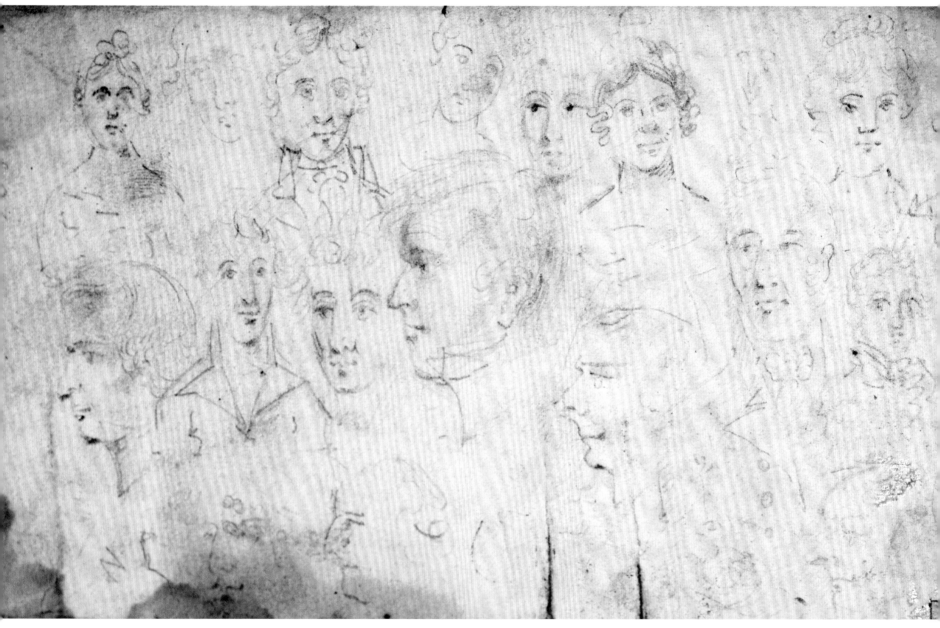

Figure 5-8
1821-inside cover

Of the other two pages of figural sketches (Figure 5-5), one could be a preparatory study for a portrait of Sarah H. Drisco March (1780–1844) (Figure 4-6).[89] Sarah was the wife of Nathaniel Bowditch March (1782–1862), Blunt's landlord on Daniel Street in 1821. In the artist's manuscript ledger book, privately owned, there is an entry dated June 30, 1821, citing her spouse paying Blunt $12.00 for a portrait.[90] In light of the label on the back of this portrait (Figure 5-7) which identifies her as the sitter, Sarah's life dates, and the ledger entry, it appears this could be the portrait cited.

If this portrait is by Blunt, it appears his skills in this genre, at least in 1821, were still developing. The artist had trouble rendering her face, especially her eyes and ears. The paint is thinly and unevenly applied and the treatment of her costume and her chair cursory and awkward. The result is a somewhat unflattering portrait of limited charm.

This judgment, however, could be a little harsh. Perhaps having a sitter pose for a formal portrait was a new experience for him and he was intimidated by the sitter. His bust studies (Figure 5-8) show he could competently capture a pose when working on a small scale unobserved. As Blunt advertised his skills as a portrait painter and an ornamental painter in 1821, it is possible he kept a separate sketchbook for his formal portraits, not yet located.

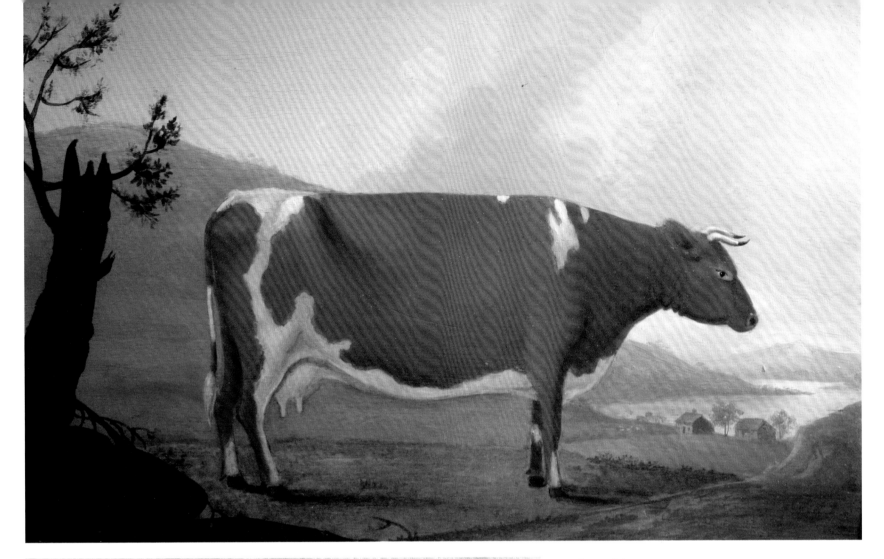

Figure 5-9
John Samuel Blunt
Portrait of Symmetry
Signed lower left "J. S. Blunt, 1823"
Inscribed on back "Portrait of Symmetry imported on
the ship Harmony, Capt. Woodward"
Oil on wood
11 × 17¼ inches
Private collection

Between 1820 and 1825, this ship was commanded by
Captain Samuel Woodward, who regularly brought cargo
into Portsmouth harbor. However, the setting behind
Symmetry is more suggestive of Lake Winnipesaukee
in the White Mountains of New Hampshire than
Portsmouth harbor. The artist has once again
manipulated the various elements of his composition to
create a more picturesque effect.

Figure 5-10
1821-54

Figure 5-11
Alvan Fisher (born Needham, Massachusetts
1792–1863)
Springfield Oxen, 1817
Oil on wood panel
20½ × 27 inches
Collection of Mr. and Mrs. Abbot W. Vose
Photograph courtesy of Mr. and Mrs. Abbot W. Vose

The engaging quality of Blunt's cow Symmetry can
undoubtedly be linked to lessons in animal painting he
learned by observing Fisher's efforts in this genre.

An interest in animals is apparent throughout the sketchbook. This was a special skill and interest of Alvan Fisher as well, another apprentice with Penniman. Like Fisher, Blunt often uses animals to animate his landscape. On occasion, he makes full-page studies of them in his 1821 sketchbook. His drawing of the dog (Figure 5-10) is a good example of this, as the dog dominates the landscape. Such a study anticipates his masterful *Portrait of Symmetry*, dated 1823 (Figure 5-9). As Nina Fletcher Little observed in her first article on Blunt, though farm animals were favorite subjects for the genre painter, not many bovines were complimented by actual "portraits."[91] Perhaps Blunt's fondness for bovines was one of the reasons he later elected to purchase land in Texas.

This page
Figure 5- 12
1821-72

Facing page:
Figure 5-13
1821-82

Figure 5-14
John Ritto Penniman trade card
Printed by Annin & Smith, circa 1822
3 × 4 inches
The Winterthur Library: Joseph Downs Collection
of Manuscripts and Printed Ephemera

Judging from the two sketchbooks, it appears the artist had little time for recreational sketching. In his 1821 sketchbook, there are only a few unstructured pages where he gives full reign to his imagination. In his 1830 sketchbook, there are none.

In one of his drawings in the 1821 sketchbook (Figure 5-12), boats, rocks, profiles, and exaggerated noses fill the page. Scarce as these scribblings are, one can sense his fun as he lets his imagination carry him. From this page, it seems Blunt sees everything as united within the larger continuum of nature.

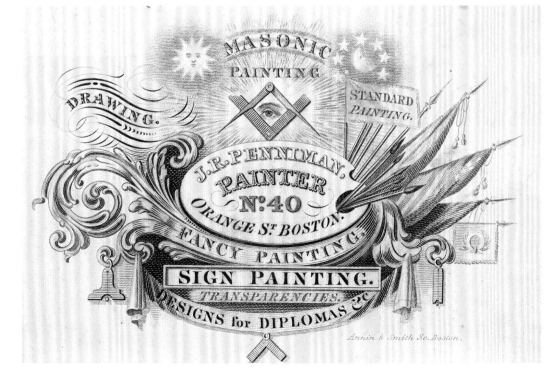

Commensurate with his early training in decorative work, his sketches for fancy work are skillful. One sketch (Figure 5-13) appears to be a study of the shield of Massachusetts with its distinctive feature of a standing native figure holding a bow and arrow. The ornamentation on the right of the same page resembles Penniman's trade card of the 1820s (Figure 5-14). This card was published by Annin & Smith, the same printers who later engaged Blunt to color their prints.

This page:
Figure 5-15
1821-8

Figure 5-16
One of three painted cornices at the Warner House,
Portsmouth, New Hampshire
Warner House Association, Portsmouth, New Hampshire

Facing page:
Figure 5-17
John Samuel Blunt
Masonic apron of Captain John Tarlton, New Castle, New Hampshire
Walley Museum, St. John's Masonic Lodge, Portsmouth, New Hampshire
Cited June 24, 1826 ledger entry, $2.25 for Samuel Neal
1819 JSB Account Book, private collection.

A second fancy sketch (Figure 5-15) resembles the painted designs found on Portsmouth fancy chairs such as those at the Rundlett-May house in Portsmouth.[92] He certainly undertook this kind of work, as the JSB 1826 Account Book has numerous entries for decorative finish work such as gilding and clouding for local furniture makers. The same sketch suggests Blunt might have painted cornices at the Warner House (Figure 5-16). In 1821, John Nathaniel Sherburne was an occupant of that house and musically inclined. In 1822, Sherburne married Blunt's first cousin Eveline Blunt. The artist was obviously close to the couple, as he presented them with his painting, *Harbor Scene*, possibly of Boston (Figure 3-28) to mark the event.

Entries found in the JSB 1819 Account Book and the JSB 1826 Account Book confirm that ornamental work remained his key source of income throughout his brief career.

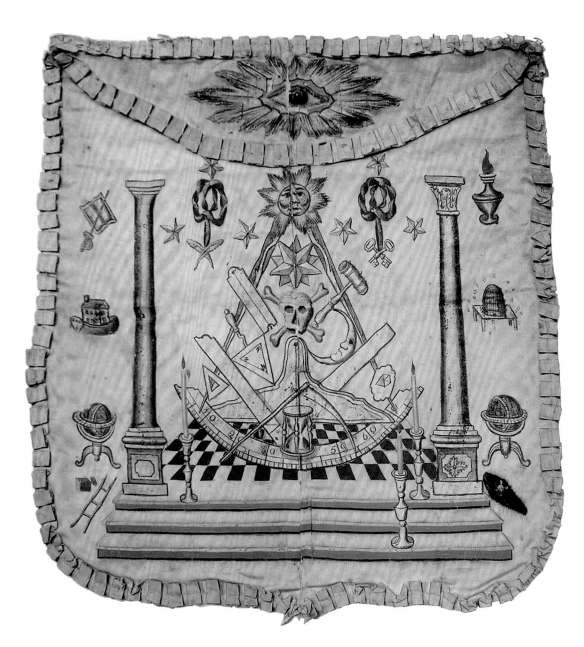

Chapter 6

Nature Was His Inspiration

This page:
Figure 6-1
1821-88
Note how lowering the horizon gives prominence to sky.

Facing page:
Figure 6-2
1821-63

True to the son and grandson of mariners, Blunt was keenly aware of climatic changes. He studied sky conditions intently, and keenly observed the effect of such changes on the landscape and on open water. His ability to capture these nuances on paper and with paint, coupled with his intimate knowledge of the local topography, undoubtedly accounts for the pronounced sense of place in his work.

Aside from their application, his drawings are a delight in themselves. They have a boldness that gives them an almost contemporary feel. As he wields his pencil with such freedom and rhythm, one senses his joy in being outside working in nature.

Twenty-two of the hundred studies in his 1821 sketchbook are inscribed "From Nature," and one of the three dated 1821 cites an actual date of July 4 (Figure 6-4). Why only some are inscribed in this manner does not seem to be related to their subject matter. For example, his sketch (Figure 6-5) although inscribed "From Nature," looks more like a picturesque view from the English Lake District than a New England view.

Blunt's *plein air* studies show why he is so convincing in his painterly expressions of nature. For example, he made detailed sketches of rock formations (Figure 6-6) and waterfalls (Figure 6-7) before executing his ambitious 1822 painting *Fanciful Landscape with Falls and Travelers on Mountain Trail* (Figure 6-8). Fanciful or imaginary landscapes continued to be favored subject matter for Blunt during the 1820s.

Figure 6-3
1821-84

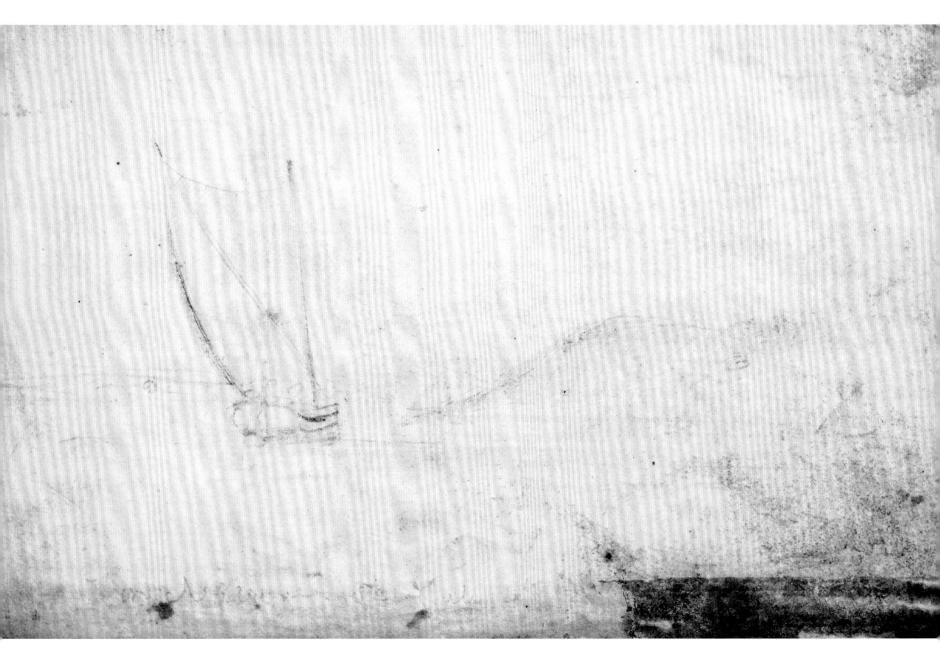

Figure 6-4
1821-11
"From Nature" "July 4 1821"

Figure 6-5
1821-80
"From Nature"

These same studies might help identify other landscapes painted by Blunt. For example, a sketch from his 1821 sketchbook (Figure 6-9) suggests a White Mountain setting of Chocorua Pond with an abbreviated jagged version of Mount Chocorua on the right. Although a painting relating to this particular drawing has yet to surface, this was a site known to the artist. In 1827, a lottery at The Portsmouth Athenæum included "a view of the Notch of the White Mountains in New Hampshire, on canvas five feet by four, drawn on the spot by Mr. Blunt in 1824."[93] In 1828, Blunt had an exhibition of paintings in his Portsmouth studio including *View of the Notch of the White Mountains* and *View of Lake Winnipissiogee*.[94]

Blunt's colleagues also made sketches of actual sites which they would turn into formal paintings in their studios. Charles Codman's *View of Twin Mountain* (Figure 6-10), signed and dated July 6, 1821, expresses a kindred interest in capturing actual scenes of the White Mountains at a specific time.[95] However, in this case the end result is more decorative than a convincing view of nature.

How Blunt transitioned from being a decorative and topographical landscape artist in the manner of Codman to a romantic landscape master is revealed by a close comparison of his two sketchbooks. In his earlier sketchbook, he extracted real views or features he had observed in nature that he later used as building blocks for his painted landscapes. By working empirically, he followed in the topographical tradition.

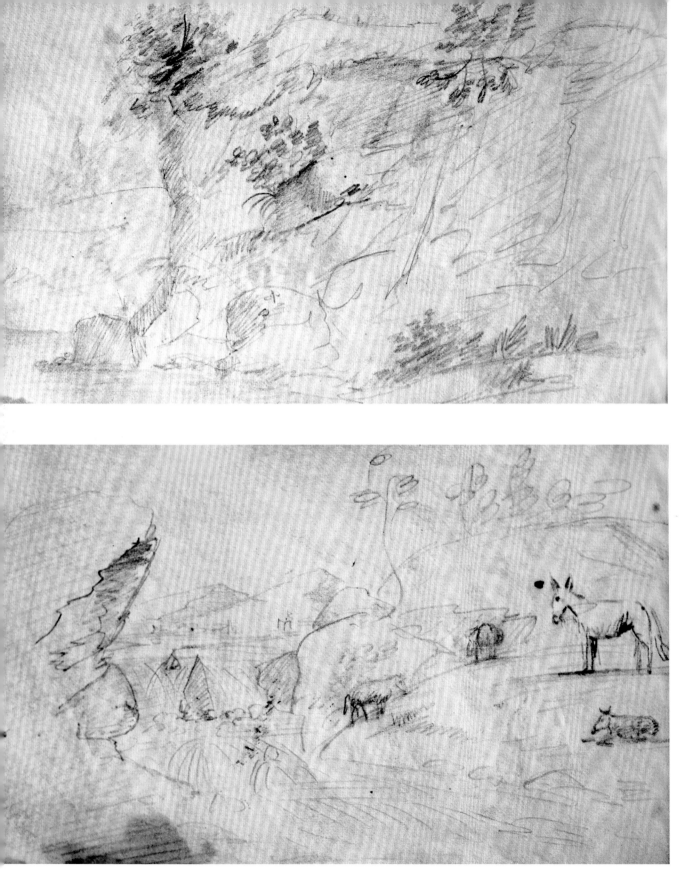

This page:
Figure 6-6
1821-56

Figure 6-7
1821-16

Facing page:
Figure 6-8
John Samuel Blunt
*Fanciful Landscape with Falls and Travelers
on Mountain Trail*
Signed lower left "Blunt 1822"
Oil on canvas
21 × 26 inches
Oxford Gallery, Rochester, New York
Photograph Greg Walker

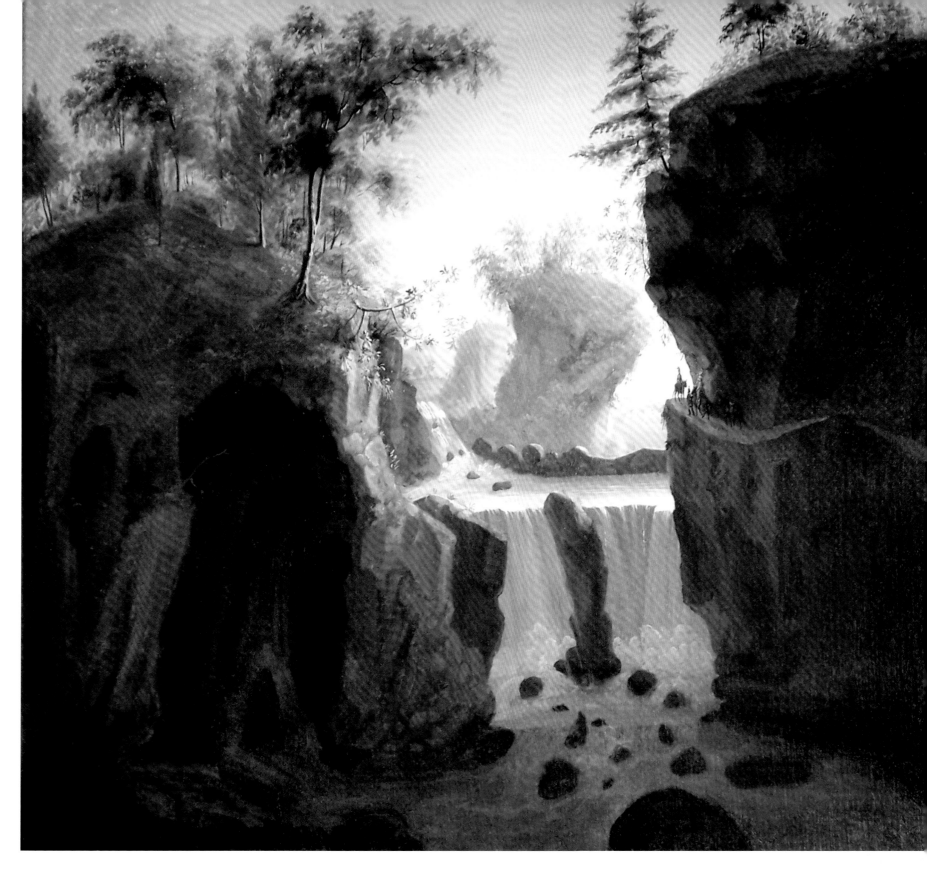

This page:
Figure 6-9
1821-12

Facing page:
Figure 6-10
Charles Codman (American, circa 1800–1842)
View of Twin Mountain, July 6, 1821
Signed and dated lower left "Charles Codman, *pinx* July 6, 1821"
Oil on panel
11¾ × 16 inches
Private collection. ©2002 Namdoc

In his 1830 sketchbook, he composed integrated landscapes that are more ideal than anything found in nature. For example, in his two sketches, one of trees, animals and mountains (Figure 6-11) and a second *An Ideal Scene* (Figure 6-12), there is an eternal quality that was not present in his earlier studies of similar subject matter. One is no longer standing in a real landscape but an idealized one in which time and circumstance are of no consequence. By creating landscapes in this manner, Blunt followed in the classical landscape tradition of French landscape artists such as Claude Lorrain (1602–1682) and Gaspard Dughet (1615–1675), known as Poussin.

Charles Cadman pinx.
July 6 1821.

Figure 6-11
1830-24
Note how this drawing is squared off to ease its
translation to a larger format such as a window shade,
painting, or wall mural.

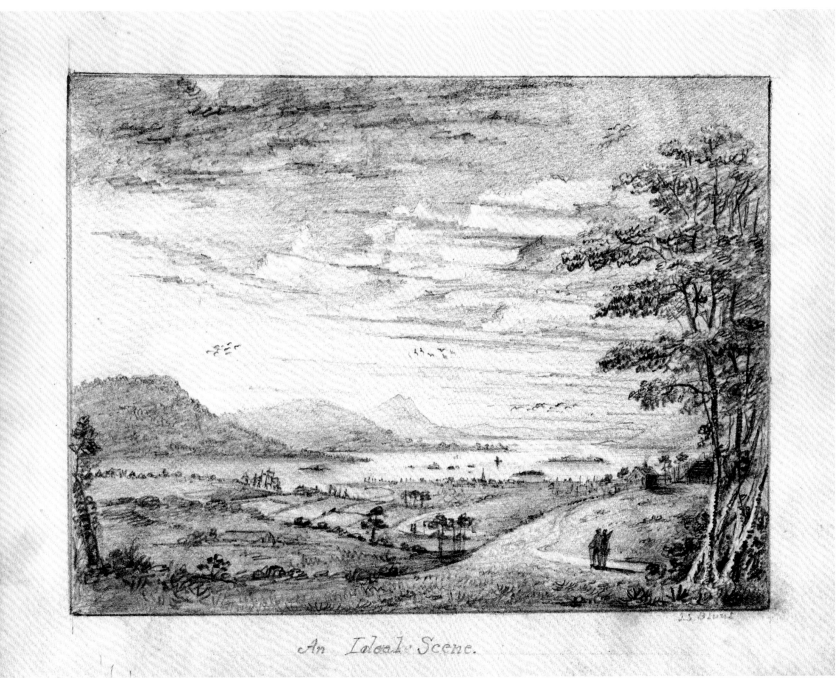

An Idcalc Scene.

Figure 6-12
1830-3
The fact that the artist titled this drawing and signed his name
on the lower right suggests he envisioned this drawing in print
form. Perhaps he had aspirations to be a lithographer, a drawer
in stone, rather than a colorist of prints by other artists as the
entries in JSB 1826 Account Book indicated he was.

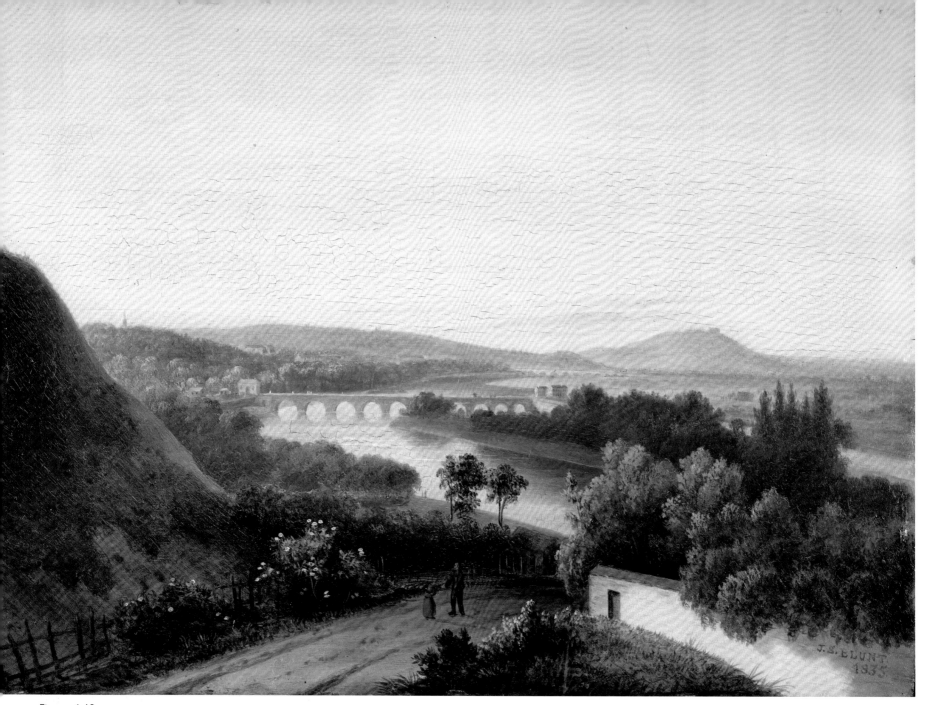

Figure 6-13
John Samuel Blunt
The Arched Bridge aka *New England River Landscape*
Signed lower right "J. S. Blunt, 1835"
Oil on panel
11 × 15 inches
Private collection
Photograph courtesy Dan Kushel, Art Conservation Department,
Buffalo State College, New York
Blunt's mastery of the principles of classical landscape design is
readily apparent in this 1835 panel.

Why are there no sketches inscribed "From Nature" in his 1830 sketchbook? His focus shifted from working *plein air* to working in the studio. He dealt with landscape as a concept rather than dealing in specifics. This approach made sublime subject matter such as rock formations, caverns, waterfalls and classical composition more appealing. This was favored subject matter in the *oeuvres* of British artists such as Alexander Cozens (1717–1786) and his son John Robert Cozens (1752–1797).[96]

Figure 6-14
1830-19

A number of Blunt's sketches in this 1830 sketchbook appear to be modeled on Alexander Cozens' ink blots after Claude Lorrain. This was a somewhat unorthodox method Cozens devised for teaching the art of landscape painting. A series of accidental blots in various color washes would be applied with sufficiently wet brushes that the design could then be transferred to another paper. This would free one's imagination sufficiently that one could then create on the transferred paper ideal landscapes of the mind much in the manner of Claude.

Figure 6-15
1830-6

Figure 6-16
John Robert Cozens (born London, England, 1752–1797)
Cavern in the Campagna
Pencil and watercolor
14¾ × 20 inches
Photo courtesy of Birmingham Museum and Art Gallery, Birmingham, England

This artist's mastery of the watercolor medium set the standard for all efforts in this genre during the eighteenth century.

For an artist like Blunt, who had no access to formal art instruction, making studies after others was a useful and practical means for learning how to create landscapes that were more balanced and distilled. As painter and printmaker John Rubens Smith (1775-1849), the son of engraver John Raphael Smith, was back in Boston in 1827, he might have had some of Cozens ink blots and etchings with him.[97] Perhaps Blunt visited Smith's drawing academy in Cornhill Square.[98] Could Smith also have instructed Blunt in the use of perspective in Blunt's drawing of what is likely a Boston street (Figure 6-17)?

Detail of *Picnick at Long Island* (Page 5)

Figure 6-17
1830-9

Conclusion

While landscape and marine subject matter was his greatest interest and love, Blunt lived in a time when there were few buyers for this kind of art in America.[99] From his earliest years at Penniman's workshop until he packed up his Boston studio, this was the genre that interested him most. When his paintings failed to attract buyers, he began to make drawings of landscapes suitable for lithography (Figure 6-12).[100] When he failed to find a market for his drawings, he turned to the land itself for sustenance. He purchased land in Texas and committed to creating a working landscape.

As a painter, Blunt's diligence and devotion to sketching scenes "From Nature" and of nature were fundamental to his progress. From his sustained studies, he was able to progress from a naïve style of painting like his *Launching of the United States Ship Washington* (Figure 4-27), to marine paintings such as *United States Ship Constitution* (Figure 4-31) rich in symbolism, to paintings that are truly majestic such as his *Boston Harbor* (Figure 6-18), a scene which is distilled to its essence.

For Blunt, his first-hand study of nature was what ensured the veracity of his views. Throughout his tragically brief career, nature remained his guide and his inspiration.

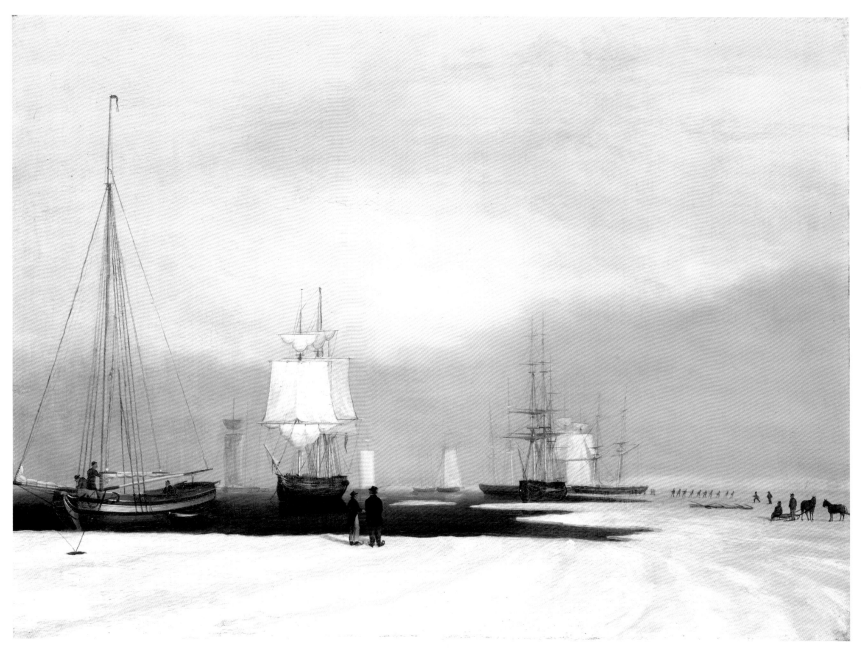

Figure 6-18

John Samuel Blunt

Boston Harbor

Inscribed on reverse "Boston Harbor, Jany 12 1835 1 mile below the Castle [Island]
looking to the East. J. S. Blunt"

Oil on panel

20½ × 28⅛ inches

Museum of Fine Arts, Boston Gift of Martha C. Karolik for the M. and M. Karolik

Collection of American Paintings, 1815-1865, 47.1240

Photograph © 2007 Museum of Fine Arts, Boston

Appendix 1. Important dates in the life of John Samuel Blunt

1798 Born March 17, Portsmouth, New Hampshire, eldest son of Captain Mark Samuel Blunt & Mary Sarah Drowne.

1802 Great fire of Portsmouth, 132 buildings burned.

1806 St. John's Church and thirteen buildings lost in fire.

1812 War with Britain.

1813 Largest great fire of Portsmouth, in which city lost nearly the entire central business district. A total of 244 buildings covering fifteen acres lost. Artist's immediate and extended family were amongst the claimants.

1814 October 1, launching of the *United States Ship Washington*, the first ship to be built at the Portsmouth Naval Shipyard, Kittery, Maine. Public celebration despite British threats to blockade the harbor.

1815 His father lost at sea when the *Portsmouth* sank off the coast of Madeira, Portugal, along with all of the crew.

1816 Artist serving an apprenticeship with John Ritto Penniman in Boston.

1819 Travels with portrait artist William P. Codman up the Merrimack River to Concord, New Hampshire.

1821 Portsmouth Directory cites him as "Ornamental and Portrait Painter." June 5, first advertisement of his painting services appears in *New Hampshire Gazette*. October 13, marries Esther Peake Colby in Boston, Massachusetts.

1822 Purchases property on Pleasant Street in Portsmouth, New Hampshire.

1825 April 2, advertises in *Portsmouth Journal*, "Drawing and Painting School."

1826 Exhibits at a new painting establishment on State Street, Portsmouth, New Hampshire.

1827 Portsmouth Directory advertised services include "Portrait and miniature Painting, Military Standard. Sign Painting, Plain and Ornamented, Landscape and Marine Painting, Masonic and Fancy. Ship Ornaments Gilded and Painted, Oil and Burnish Gilding, Bronzing & c. & c." Lottery exhibit at The Portsmouth Athenæum. (August 23, *Commercial Advertiser*).

1828 Holds a painting exhibition at State Street which includes full-length portraits by others, as well as his own views of Niagara Falls.

1829 Exhibits for the first time at Boston Athenæum. Death of his mother Mary Drowne Blunt. His brother Alfred, aged sixteen, placed under guardianship with relatives in Portsmouth, New Hampshire.

1830 Artist moves to Boston, Massachusetts, sets up studio at 62 Cornhill.

1835 Packs up Boston studio and travels west to purchase land in Texas. Becomes ill and dies at age thirty-seven aboard ship on a voyage home from New Orleans to Boston.

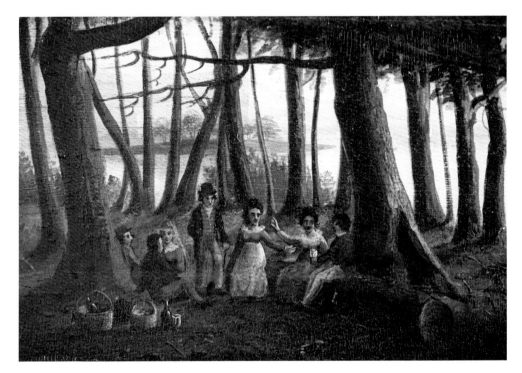

Detail of *Picnick at Long Island* (Page 5)

Appendix 2. Descendants of Mark Samuel Blunt

Each family member who has progeny is assigned a unique number cited on the far left of their name. To follow their line, follow their assigned number to the next generation listing.

Generation No. 1

1. MARK SAMUEL[4] BLUNT (JOHN[3], JOHN[2], WILLIAM[1]) was born July 07, 1770 in New Castle, New Hampshire, and was lost at sea January, 1815. He married MARY FRANCES DROWNE December 11, 1796 in Portsmouth, New Hampshire. She was daughter of SAMUEL DROWNE and MARY PICKERING. She was born May 09, 1776 in Portsmouth, New Hampshire, and died June 23, 1829 in Portsmouth, New Hampshire.

Children of MARK BLUNT and MARY DROWNE are:

2.	i.	JOHN SAMUEL[5] BLUNT, b. March 17, 1798, Portsmouth, New Hampshire; d. August 25, 1835, at sea enroute to Boston from New Orleans.
	ii.	THOMAS JEFFERSON BLUNT, b. April 11, 1800, Portsmouth, New Hampshire; d. December 16, 1801, Portsmouth, New Hampshire.
	iii.	MARK SAMUEL BLUNT, b. June 11, 1802, Portsmouth, New Hampshire; d. July 25, 1824, Boston, Massachusetts.
	iv.	DANIEL BLUNT, b. March 29, 1808, Portsmouth, New Hampshire; d. May 03, 1808, Portsmouth, New Hampshire.
	v.	ALMIRA BLUNT, b. October 16, 1809, Portsmouth, New Hampshire; d. October 29, 1809, Portsmouth, New Hampshire.
3.	vi.	ALFRED MONROE BLUNT, b. November 20, 1813, Portsmouth, New Hampshire; d. May 10, 1888, Cambridge, Massachusetts.

Generation No. 2

2. JOHN SAMUEL[5] BLUNT (MARK SAMUEL[4], JOHN[3], JOHN[2], WILLIAM[1]) was born March 17, 1798 in Portsmouth, New Hampshire, and died August 25, 1835 at sea enroute to Boston from New Orleans. He married ESTHER PEAKE COLBY October 13, 1821 in Boston, Massachusetts, daughter of JOSEPH COLBY and MARY PEAKE. She was born March 4, 1801 in Newburyport, Massachusetts, and died August 12, 1872 in Milford, Massachusetts.

Children of JOHN BLUNT and ESTHER COLBY are:

4.	i.	FRANCES MARY[6] BLUNT, b. December 23, 1821, Portsmouth, New Hampshire; d. February 20, 1872, Worcester, Massachusetts.
	ii.	ANGELICA KAUFFMAN BLUNT, b. November 02, 1823, Portsmouth, New Hampshire; d. June 25, 1826, Portsmouth, New Hampshire.
5.	iii.	MICHAEL ANGELO BLUNT, b. January 28, 1826, Portsmouth, New Hampshire; d. February 03, 1882, Pueblo, Colorado.
	iv.	CHARLOTTE ANGELICA BLUNT, b. July 25, 1829, Portsmouth, New Hampshire; d. June 19, 1887, Germany.
6.	v.	MARK LEONARDO BLUNT, b. May 23, 1832, Boston, Massachusetts; d. June 18, 1897, Pueblo, Colorado.
7.	vi.	MARTHA WASHINGTON BLUNT, b. September 02, 1834, Boston, Massachusetts; d. May 06, 1921.

3. ALFRED MONROE[5] BLUNT (MARK SAMUEL[4], JOHN[3], JOHN[2], WILLIAM[1]) was born November 20, 1813 in Portsmouth, New Hampshire, and died May 10, 1888 in Cambridge, Massachusetts. He married PLOOMY COLBY November 24, 1838 in Boston, Massachusetts. She was the daughter of JOSEPH COLBY and MARY PEAKE and the younger sister of Esther Peake Colby, the artist's wife. Also known as Pluma, she was born in 1817 in Newburyport, Massachusetts and died 1897 in Cambridge, Massachusetts.

Children of ALFRED BLUNT and PLOOMY COLBY are:

8.	i.	MARY[6] BLUNT, b. March 27, 1840, Boston, Massachusetts; d. December 22, 1931.
	ii.	ELEANOR AUGUSTA BLUNT, b. November 09, 1842, Boston, Massachusetts; died before 1930; m. EBENEZER FISHER, June 18, 1878, Boston, Massachusetts.

9. iii. GEORGE S. BLUNT, b. February 14, 1843, Roxbury, Massachusetts; d. 1932, California.

iv. FRANCESCA ANGELICA BLUNT, b. January 01, 1849, Cambridge, Massachusetts; d. December 19, 1934, Cambridge, Massachusetts; m. CHARLES FREEMAN HOLT, April 12, 1892, Boston, Massachusetts.

Generation No. 3

4. FRANCES MARY[6] BLUNT (JOHN SAMUEL[5], MARK SAMUEL[4], JOHN[3], JOHN[2], WILLIAM[1]) was born December 23, 1821 in Portsmouth, New Hampshire, and died February 20, 1872 in Worcester, Massachusetts. She married STEPHEN WOODWORTH in 1845. He was the son of ELIAS WOODWORTH and SARAH JEFFERSON. He was born May 31, 1815 in Nova Scotia and died December 26, 1854 in Worcester, Massachusetts.

Children of FRANCES BLUNT and STEPHEN WOODWORTH are:
i. JOHN BLUNT[7] WOODWORTH, b. May 16, 1845, Boston, Massachusetts; d. June 16, 1893, Worcester, Massachusetts; m. ANNIE W. DAGGETT, November 01, 1875, Worcester, Massachusetts.
10. ii. WILLIAM JEFFERSON WOODWORTH, b. December 31, 1847, Boston, Massachusetts; d. 1932.

5. MICHAEL ANGELO[6] BLUNT (JOHN SAMUEL[5], MARK SAMUEL[4], JOHN[3], JOHN[2], WILLIAM[1]) was born January 28, 1826 in Portsmouth, New Hampshire, and died February 03, 1882 in Pueblo, Colorado. He married PAMELIA BARKER DRAPER June 19, 1850 in Boston, Massachusetts. She was the daughter of Jeremiah Adams Draper and Miriam Sandborn. She was born September 11, 1824 in Boston, Massachusetts, and died February 17, 1900.

Children of MICHAEL BLUNT and PAMELIA DRAPER are:
11. i. JANE HODGES[7] BLUNT, b. July 19, 1851, Boston, Massachusetts; d. 1920.
12. ii. PAMELIA ADAMS BLUNT, b. July 19, 1851, Boston, Massachusetts; d. 1902.
iii. STEPHEN WOODWORTH BLUNT, b. April 14, 1855, Boston, Massachusetts; d. July 01, 1895, Milford, Massachusetts; m. ELEANOR A. MCLAUGHLIN, September 27, 1892, Milford, Massachusetts.
iv. ESTHER FRANCES BLUNT, b. May 28, 1859, Milford, Massachusetts; d. 1914; m. ISAIAH W. EMERSON, December 12, 1895, Chelsea, Massachusetts.
v. MARK ANGELO BLUNT, b. March 12, 1861, Milford, Massachusetts; d. April 02, 1867, Milford, Massachusetts.
vi. MARK ANGELO BLUNT, b. 1867; d. 1867.
vii. JOHN SAMUEL BLUNT, b. July 12, 1869, Massachusetts; d. January 01, 1892, Milford, Massachusetts.

6. MARK LEONARDO[6] BLUNT (JOHN SAMUEL[5], MARK SAMUEL[4], JOHN[3], JOHN[2], WILLIAM[1]) was born May 23, 1832 in Boston, Massachusetts, and died June 18, 1897 in Pueblo, Colorado. He married (1) MARGELIA L. CLAY February 25, 1860 in Golden, Colorado. He married (2) LINDA JANE STOUT July 02, 1871 in Pueblo, Colorado, daughter of ENOCH STOUT and PRISCILLA BRYANT. She was born February 19, 1844 in Gosport, Indiana, and died January 12, 1902.

Children of MARK BLUNT and LINDA STOUT are:
13. i. EDWARD ANGELO[7] BLUNT, b. March 17, 1872, Colorado; d. 1924, Denver, Colorado.
14. ii. LAURENCE CALVIN BLUNT, b. December 03, 1873, Pueblo, Colorado; d. December 15, 1941.
iii. MARK HAROLD BLUNT, b. November 13, 1875, Pueblo, Colorado; d. January 27, 1943; m. DELLA FERGUSON.
15. iv. FREDERICK CHARLES BLUNT, b. November 14, 1877, Pueblo, Colorado; d. January 31, 1964, Denver, Colorado.
16. v. RALPH WILLIAM BLUNT, b. June 05, 1880, Pueblo, Colorado; d. May 25, 1960, San Clemente, California.
vi. FLORENCE ESTHER BLUNT, b. April 13, 1884, Pueblo, Colorado; d. June 07, 1969, Denver, Colorado.

7. MARTHA WASHINGTON[6] BLUNT (JOHN SAMUEL[5], MARK SAMUEL[4], JOHN[3], JOHN[2], WILLIAM[1]) was born September 02, 1834 in Boston, Massachusetts, and died May 06, 1921. She married GEORGE FORREST WILLIAMS May 06, 1857 in Worcester, Massachusetts. He was born April 1837 in Lancaster, Massachusetts.

Children of MARTHA BLUNT and GEORGE WILLIAMS are:
 i. CHARLES BURNHAM[7] WILLIAMS, b. September 02, 1858.
 ii. ALICE AUGUSTA WILLIAMS, b. July 13, 1861.
 iii. CHARLOTTE COLBURN WILLIAMS, b. September 20, 1864, Massachusetts.

8. MARY[6] BLUNT (ALFRED MONROE[5], MARK SAMUEL[4], JOHN[3], JOHN[2], WILLIAM[1]) was born March 27, 1840 in Boston, Massachusetts, and died December 22, 1931. She married MARK J. FOLSOM May 01, 1860 in Charlestown, Massachusetts, son of BENJAMIN FOLSOM and CHARLOTTE. He was born December 6, 1836 in Kennebunk, Maine, and died January 1907.

Child of MARY BLUNT and MARK FOLSOM is:
 i. MARY JOSEPHINE[7] FOLSOM, b. April 18, 1861, Charlestown, Massachusetts; d. 1929; m. UNKNOWN LAMPREY.

9. GEORGE S.[6] BLUNT (ALFRED MONROE[5], MARK SAMUEL[4], JOHN[3], JOHN[2], WILLIAM[1]) was born February 14, 1843 in Roxbury, Massachusetts, and died 1932 in Los Angeles, California. He married ELEANOR DOWNING HATHAWAY September 10, 1868 in Boston, Massachusetts, daughter of ADONIRAM HATHAWAY and SARAH SARGENT. She was born August 17, 1847 in Boston, Massachusetts, and died March 26, 1883, Somerville, Massachusetts.

Children of GEORGE BLUNT and ELEANOR HATHAWAY are:
 i. HARRY ALFRED[7] BLUNT, b. December 03, 1870, Boston, Massachusetts; d. March 05, 1872, Boston, Massachusetts.
 ii. MABEL SARGEANT BLUNT, b. December 27, 1871.
 iii. EDITH COLBY BLUNT, b. June 27, 1874, Boston, Massachusetts.

Generation No. 4

10. WILLIAM JEFFERSON[7] WOODWORTH (FRANCES MARY[6] BLUNT, JOHN SAMUEL[5], MARK SAMUEL[4], JOHN[3], JOHN[2], WILLIAM[1]) was born December 31, 1847 in Boston, Massachusetts, and died 1932. He married SARA ELIZABETH BABCOCK February 22, 1880 in Worcester, Massachusetts, daughter of HENRY E. BABCOCK. She was born November 21, 1858, in Fitchburg, Massachusetts.

Children of WILLIAM WOODWORTH and SARA BABCOCK are:
 i. ALBERT SHEPARD[8] WOODWORTH, b. September 30, 1882, Colorado; d. November 1968, Connecticut
 ii. ZELLA F. WOODWORTH, b. October 15, 1883, Colorado; d. October 1967, Cambridge, Massachusetts.
 iii. DOROTHY D. WOODWORTH, b. November 12, 1896, Bolton, Massachusetts; d. August 10, 1907, Boston, Massachusetts.

11. JANE HODGES[7] BLUNT (MICHAEL ANGELO[6], JOHN SAMUEL[5], MARK SAMUEL[4], JOHN[3], JOHN[2], WILLIAM[1]) was born July 19, 1851 in Boston, Massachusetts, and died 1920. She married ALBERT F. SADLER August 14, 1878, in Medford, Massachusetts, son of ALBERT SADLER and MARTHA PIERCE.

Detail of Figure 6-13

Child of JANE BLUNT and ALBERT SADLER is:
 i. ROY ANGELO[8] SADLER, b. August 1882; d. 1934.

12. PAMELIA ADAMS[7] BLUNT (MICHAEL ANGELO[6], JOHN SAMUEL[5], MARK SAMUEL[4], JOHN[3], JOHN[2], WILLIAM[1]) was born July 19, 1851, in Boston, Massachusetts, and died 1902. She married JAMES B. LEONARD May 11, 1875, in Milford, Massachusetts, son of JEREMIAH LEONARD and JOANNA. He was born February 1845 in Vermont.

13. EDWARD ANGELO[7] BLUNT (MARK LEONARDO[6], JOHN SAMUEL[5], MARK SAMUEL[4], JOHN[3], JOHN[2], WILLIAM[1]) was born March 17, 1872 in Colorado, and died 1924 in Denver, Colorado. He married MARTHA EGGERT 1897. She was born c. 1873. In 1930, she is cited as a resident of Queens, New York, l/w her two children.

Children of EDWARD BLUNT and MARTHA EGGERT are:
 i. EDWARD A. BLUNT, b. 1915 , Jasper, Michigan, d. circa 1979.
 ii. LINDA J. BLUNT, b. 1917, Jasper, Michigan

14. LAURENCE CALVIN[7] BLUNT (MARK LEONARDO[6], JOHN SAMUEL[5], MARK SAMUEL[4], JOHN[3], JOHN[2], WILLIAM[1]) was born December 03, 1873 in Pueblo, Colorado, and died December 15, 1941. He married RUTH ESTHER HOWE, daughter of WILFRED HOWE and ELIZA ARCHER. She was born October 1, 1880 in Walnut, Kansas, and died October 11, 1961 in Denver, Colorado.

Children of LAURENCE BLUNT and RUTH HOWE are:
 i. LAURENCE CALVIN BLUNT, b. September 06, 1904, Denver, Colorado; d. 1985, Denver, Colorado.
 ii. ROBERT MATTESON BLUNT, b. October 21, 1916, Denver, Colorado; d. August 03, 1995, Denver, Colorado.

15. FREDERICK CHARLES[7] BLUNT (MARK LEONARDO[6], JOHN SAMUEL[5], MARK SAMUEL[4], JOHN[3], JOHN[2], WILLIAM[1]) was born November 14, 1877 in Pueblo, Colorado, and died January 31, 1964 in Denver, Colorado. He married FLORENCE ELIZABETH EBERHARDT March 16, 1904, daughter of CHARLES EBERHARDT and MARGARET JONES. She was born March 14, 1884 in Salt Lake City, Utah and died November 1982 in Denver, Colorado.

Children of FREDERICK BLUNT and FLORENCE EBERHARDT are:
 i. CHARLES EDWARD BLUNT, b. April 15, 1905, Kansas City, MO; d. 1987.
 ii. MARGARET LINDA JANE BLUNT, b. Nov. 21, 1906; d. April 27, 2003.
 iii. MARTHA LOU BLUNT, b. June 13, 1909, Pueblo, Colorado; d. May 1, 1937.

16. RALPH WILLIAM[7] BLUNT (MARK LEONARDO[6], JOHN SAMUEL[5], MARK SAMUEL[4], JOHN[3], JOHN[2], WILLIAM[0]) was born June 05, 1880 in Pueblo, Colorado, and died May 25, 1960 in San Clemente, California. He married THERESA ADELAINE DONNELLY in 1900.

Children of RALPH BLUNT and THERESA DONNELLY are:
 i. JOSEPHINE BLUNT, b. July 1, 1901; d. April 1976, San Clemente, California.
 ii. MARK L. BLUNT, b. June 3, 1903; d. July 10, 1984, San Clemente, California.

Endnotes

1. "Sam" might have become his nickname to distinguish him from his older first cousin John Blunt (born Portsmouth, New Hampshire, December 10, 1796-Brooklyn, New York, June 17, 1870), the son of Charles E. Blunt, the artist's uncle. This John was the brother of Eveline Blunt, the wife of John Nathaniel Sherburne, owners of the Warner House, and the spouse of Mehitable Massey Marsh, a daughter of the wealthy Portsmouth merchant Matthew Marsh. John Blunt held a pew at St. John's, briefly operated a hardware store with his brother-in-law John Sherburne in Portsmouth, New Hampshire, owned a share of The Portsmouth Athenæum, and attended many of the social gatherings, including the 1823 Centennial Ball, before leaving Portsmouth in 1829 for Brooklyn.

2. Samuel Drowne, guardianship papers, Division of Records Management and Archives, Concord, New Hampshire, old series 8418.

3. "Roster of Master Taft's students." See Charles W. Brewster. *Rambles about Portsmouth*. Reprint. Somersworth, New Hampshire: New Hampshire Publishing Company (1972) p. 319.

4. Jessica Nicoll. "The Real Pioneer of Art in this City: Charles Codman and the Rise of Landscape Painting in Portland, Maine." *Charles Codman. The Landscape of Art and Culture in 19th-century Maine*. Portland Museum of Art, Portland, Maine, 2002, p.13. For further information on Penniman, see Carol Damon Andrews, "John Ritto Penniman (1782–1841) an ingenious New England artist," *The Magazine Antiques*, Vol. 120, No. 1 (July, 1981) pp. 147–170. For an in-depth discussion of the role of commercial pictorial printmakers and publishers as an alternative for art education, see Georgia B. Barnhill, Diana Korzenik and Caroline F. Sloat, *The Cultivation of Artists in Nineteenth-Century America* (Worcester, Massachusetts: American Antiquarian Society, 1997).

5. By naming his children Michael Angelo, Mark Leonardo, and Angelica Kauffman, it is apparent Blunt took his career as an artist seriously. Perhaps he had been inspired by John Rubens Smith who was himself named for the Flemish master Rubens by his father John Raphael Smith. In 1807, Smith was a founder of the Probationary Academy of Arts, a professional organization modeled on the British Royal Academy, which included amongst its members Penniman, Blunt's teacher (Catharina Slautterback. *Boston 1735–1818*. Exhibition catalog. Boston, Massachusetts: Museum of Fine Arts. April 18–October 12, 1975, p. 300).

6. Jessica F. Nicholl. Catalog of the Exhibition. *Meet Your Neighbors. New England Portraits, Painters and Society 1790–1850*. Old Sturbridge Village, 1993, p. 114. As related in Nathan Negus diary entries, November 22, 1819, Negus, J. Samuel Blunt, William P. Codman and S. D. Childs formed a new Constitution for the Society. Their first meeting of nine members took place December 4, 1819. Nathan Negus Memorandum Book for 1819, 1820 and 1821. Negus Papers, Archives of American Art, Smithsonian Institution, microfilm #611. Citation kindly provided by Tom Hardiman.

 Information on the three public institutions they visited is sparse. According to C. H. Snow's *Geography of Boston* (Boston: Carter & Hendee, 1830), the New England Museum was established at No. 75 Court Street in 1818. It consisted primarily of natural and artificial curiosities as well as busts of eminent citizens and other public figures (p. 52). The Gallery of Fine Arts occupied the third floor of the brick building at the rear of the Boston Athenæum and was primarily for display of paintings (p. 106).

 For a case study of the impact of the study of art outside of formal art education institutions in New Hampshire, see Diana Korzenik. *Drawn to Art. A Nineteenth-Century American Dream*. Hanover, New Hampshire: University Press of New England, 1985.

7. *Seeking the Realization of a Dream. The Paintings of Alvan Fisher.* Exhibition catalog. May 13–October 21, 2001. Heritage Plantation of Sandwich, Cape Cod, Massachusetts, p. 12. Mabel Munson Swan, "The unpublished notebooks of Alvan Fisher." *Antiques* (August 1955) pp. 126–129.

8. According to the owner of this manuscript, a transcript of the trip along with his research will be forthcoming. Email correspondence March 26, 2007.

9. In a later sale listing, this structure was described as a three-story wooden house completely calculated for two small families (*Portsmouth Journal*, February 14, 1835, p. 3). In the 1950s, it was deemed an impediment to traffic and demolished. The site is now occupied by a senior housing complex.

10. An announcement that the school would commence about June 1 appeared on May 3, 1825 in the *New Hampshire Gazette*.

11. According to Richard M. Candee, in 1826 Blunt's studio would

have been in one of two structures on Pleasant Street between Market Square and State Street: the one built in 1826 and still standing, or the structure opposite it which predated the granite United States Custom House built in 1857.

12. "Exhibition of Paintings." The public are respectfully informed that Six Views of Niagara Falls are now in Exhibition in the Chamber over the Book Store of Childs & March (*New Hampshire Gazette.* Tuesday, April 22, 1828, 3:4). Tickets for admission for forty children are recorded in John S. Blunt Manuscript ledger day book 1826–1835. Collection of The Portsmouth Athenæum, S855, hereafter called JSB 1826 Account Book, entry p. 10.

13. "Mr. Blunt's Paintings." *Commercial Advertiser*, Thursday, August 23, 1827, p. 3, col. 2.

14. "Exhibition of Paintings for Three Weeks Only." (Open evenings and brilliantly illuminated). N.B. the entrance to Mr. Blunt's painting room will be (for the present) through Mr. Hutchings store." "Mr. Blunt's Exhibition of Paintings," *Portsmouth Journal of Literature and Politics*, November 8, 1828, Vol. XXXIX, issue 45, page 3. Note that there are no purchases for this exhibit cited in the JSB 1826 Account Book, nor is there any indication of who owned the portraits he was exhibiting.

15. Entry number 163. Erroneously ascribed to a Joseph Blunt of Portsmouth.

16. Blunt worked at four locations in Boston: 62, 60 and 54 Cornhill, and finally at 11 Lucas Place.

17. Letter addressed to his wife "Mrs. Esther P. Blunt, Haverhill, Massachusetts." Private collection.

18. *M. & M. Karolik. Collection of American Water Colors and Drawings. 1800–1875*, Vol. 1. Boston, Massachusetts: Museum of Fine Arts, 1962, p. 156.

19. Letter was addressed "Mrs. Esther P. Blunt, Boston, Massachusetts. To the care of Alfred M. Blunt [the artist's brother]." Private collection.

20. Land title. Houston, Texas. 4428.4 acres. Original Grantee John S. Blunt. Patent No. 787, Patent Vol. 21. According to Galen Greaser, Texas Land Office, the only out-of-pocket expenses Blunt would have incurred were approximately $150–160. This would include the cost of preparing the land title document, a certificate of good character to ensure he was fit for admittance to the colony, the survey, and a land tariff of approximately 3–4¢ an acre. Most undeveloped land in the United States at this time was about $1.25 an acre.

21. John S. Blunt. Estate inventory, September 12, 1836. Massachusetts State Archives, Morrissey Blvd., Boston, Massachusetts. Record 31283, Book 214, page 39. Executors were his wife Esther, Joseph Colby and Elisha Tower.

22. JSB 1826 Account Book, p. 81. Entry dated March 26, 1832: "Dr. King making drawing of electrical machine $2.00."

23. 1850 Federal Census, Boston, Massachusetts, 12th Ward, September 19, 1850. Family #706, lines 20–32. No occupation is listed for Esther, age 49, Charlotte, age 21, or Martha, age 15. Son Mark, age 18, is cited as a clerk.

24. Mark Leonardo at the age of 12 had been obliged to earn a living. He secured employment first in a bookstore and subsequently learned the trade of a printer. Email correspondence July 18, 2005, Robert Matteson Blunt, Jr. Mark was one of the co-partners of Mechanics' Mining and Trading Company instituted in Boston, Massachusetts, March 3, 1859. This company, later known as Boston Trading Company, was the founder of Golden, Colorado. Mark was the recording secretary for the company and one of the first to settle there. His records were gifted to the Golden Pioneer Museum in 1937 by his son Laurence Calvin Blunt. See *Colorado Transcript*, Golden, Colorado, June 17, 1937.

25. 1860 Federal Census, Worcester, Massachusetts. M653, roll 527, p. 170.

26. Michael Angelo Blunt was educated in Boston and a printer by trade. He worked for the *Boston Journal* prior to moving to Milford, Massachusetts and publishing the *Milford Journal.*

27. For example, in a letter from Martha Blunt Williams, the artist's daughter, Winthrop, Massachusetts, dated Dec. 27, 1915, addressed to her nephew Bob [Blunt], Pueblo, Colorado, she mentions a silver spoon made by T. Drown, brother of his great-grandmother." Private collection.

28. Dorothy Adlow. "Early New England Paintings—Maine and New Hampshire Paintings on Exhibition [Doll and Richards Gallery, Boston]." *The Christian Science Monitor.* Boston, Monday, June 23, 1947, p.4. Clipping found in Papers of Nina Fletcher Little (Historic New England). Library Archives, Boston, Massachusetts.

29. Nina Fletcher Little. "J. S. Blunt, New England Landscape Painter." *Antiques* 54, No. 3 (September 1948), pp. 172–174.

30. Collection of New Bedford Whaling Museum, New Bedford, Massachusetts.

31. Dr. Robert Bishop, "John Blunt: The man, the artist, and his times."

The Clarion. New York: Museum of American Folk Art, March 7–May 4, 1980. Bishop never had full access to the JSB 1819 Account Book he cites in his catalogue. He was relying on citations shared with him by Dr. Dorothy Vaughan and the owner of the Account Book.

32. According to the owner of the JSB 1819 Account Book, "...this ledger book contains several pages of pencil sketches of various kinds. When each was done in that nearly seven-year period is unknown. Some ledger pages are clearly missing and may have contained sketches that were the basis of subsequent oil paintings." Email correspondence March 26, 2007.

33. If Bishop's hypothesis was correct, there should be an entry for the portraits of Leonard Cotton and his wife in the JSB 1826 Account Book. There is not. As was the case in the JSB 1819 Account Book, Cotton is invoiced for fire buckets and other ornamental work. There is still the possibility that the artist kept a separate ledger book for his portraits.

34. The same watermark is found on a North Reading, Massachusetts document dated 1822, Downs Collection, Winterthur, DE. (Debora Dyer Mayer, Conservator of Art and Historic Artifacts on Paper. Conservation Assessment and Treatment Proposal. Portsmouth, New Hampshire. January 5, 2007).

35. For example, a rocking chair, private collection, has a typewritten label: "The latter part of May [date not visible] this rocking chair was purchased by Laurence C. Blunt, Denver, Colorado, from Mrs. Frances A. Holt (1849–1934) for the sum of $25. The chair is to remain in the possession of Mrs. Holt during her lifetime. Witness Zella F. Woodworth." Mrs. Holt was the daughter of Alfred Blunt, the artist's brother and a cabinetmaker. Zella Woodworth (1883–1967), the witness, was the artist's great-granddaughter by his oldest daughter Frances. See Appendix 2. After Mrs. Holt's passing, Zella moved into her house on 50 Cottage Street, Cambridge, Massachusetts.

36. In 1984, Robert Matteson Blunt wrote *A Concise History of the Blunts of Boston, Massachusetts, Golden Pueblo, and Denver, Colorado*, which he distributed to family members. In 1987, he donated manuscript material concerning Mark Leonardo Blunt to Colorado State Historical Society, Denver, Colorado, MSS #1211. Materials date 1859–1872 and mostly concern Boston Trading Company, also known as Mechanics' Mining and Trading Company. See also MSS #1204. In 1987, Robert Matteson Blunt placed his genealogy papers on deposit at the Foothills Genealogical Society, Lakewood, Colorado. Thanks to their on-line guide and the intervention of Jack Davidson, contact was made with the artist's living descendants.

37. Email correspondence October 3, 2006, Jack Davidson, Lakewood, Colorado, formerly volunteer genealogist, Foothills Genealogical Society.

38. Pleasant Street Portsmouth property deed (May 4, 1835, 276.459, Rockingham County Court House, Brentwood, New Hampshire) Alfred is cited as a cabinetmaker of Boston. It is not yet established when Alfred moved to Vermont. In the 1845 Boston directory he is cited as a pianoforte maker with a house on 17 Porter Street. His youngest daughter Francesca is cited as born in Massachusetts in 1849. In 1855 there is no listing for him in the Boston directory. He then appears in the 1860 Federal Census, cited as a resident farmer of Guildhall, Essex County, VT (M653, roll 1320, p. 803). In the 1865 Boston directory (published Adams, Sampson & Co.), an Alfred M. Blunt, pianomaker, is cited with a house on 63 Camden Street.

39. 1860 Federal Census, Guildhall, Essex County, VT, M653, roll 1320, p. 806.

40. In a letter from Doyle's Ranch, Heurfano, Colorado, February 9, 1866, Mark Leonardo remarks to his mother Esther Colby Blunt:

Detail of 1821-49

"Uncle Alfred's health has improved wonderfully since he got out here." Private collection. The visit appears to have been just that, though, as the 1870 Boston directory cites an Alfred M. Blunt, pianomaker, house 43 Chester. Note that tuberculosis was a recurrent health problem for the Blunt family. Mark Leonardo's tuberculosis prompted him to go west. His older sister Frances suffered with a lung complaint, as did the artist's brother Alfred. Some have speculated that John Samuel Blunt might have had it too and that is why he contemplated life outdoors working as a rancher in Texas.

41. Florence was an employee in Training Department of R. H. White Company, a Boston department store. "Testimonial banquet to Florence E. Blunt," *The White Star*. Boston, Massachusetts. January 20, 1926.

42. 1831 Boston directory cites "John S. Blunt, painter, 62 Cornhill, house Castle Street" 1832 Boston directory cites "John S. Blunt, painter, 54 Cornhill, house Castle Street." 1835 directory cites "John S. Blunt, painter, 11 Lucas Place."

43. Engravers William B. Annin and George Girdler Smith operated the printing company Annin & Smith & Co. Lithographers, 61 Cornhill, Boston from 1831–1833. In addition to their architectural views such as the State House in Concord, New Hampshire, the company was known for their city views and their maps. See Sally Pierce and Catharina Slautterback, *Boston Lithography 1825–1880*. Boston, Massachusetts: Boston Athenæum, 1991.

44. For details see Portsmouth Directory containing the names of the Inhabitants, their Occupation…Portsmouth, New Hampshire: Wibird Penhallow, 1821. Hereafter known as Portsmouth Directory.

45. Richard M. Candee, "Social Conflict and Urban Rebuilding: The Portsmouth, New Hampshire Brick Act of 1814," *Winterthur Portfolio* XXXIII (1997) pp. 119–126.

46. For architectural development in this period, see Richard M. Candee, *Building Portsmouth. The Neighborhoods and Architecture of New Hampshire's Oldest City*. New Edition. Revised and Expanded. Portsmouth, New Hampshire: Portsmouth Advocates, 2006. For the analysis of the local craft industry, see Johanna McBrien, "Portsmouth Furniture Making, 1798–1837." *Portsmouth Furniture Masterworks from the New Hampshire Seacoast*. Hanover, New Hampshire: University of New England Press, 1993, pp. 58–72.

47. This trip was undertaken with his colleague William P. Codman, a portrait painter. A manuscript diary kept by Blunt describing their 1819 journey is not available for study.

48. Blunt's painting room had been earlier occupied by George Dame. In his 1811 advertisement, Dame cites his skills as a portrait and ornamental painter and notes his proximity to Mr. C. Pierce's Book-Store in Daniel Street. See *Portsmouth Oracle* advertisement, September 7, 1811. Reference shared by Richard M. Candee.

49. December 15, 1810 *Portsmouth Oracle* advertisement, March notified joiners he has "5000 square feet of trunk woods for sale as well as mattrasses [sic], fire buckets, trunks, sleigh harnesses, bear-skins, sleigh bells, and c." January 5, 1811, he advertised bear skins for sale. Also in the *Oracle,* on May 12, 1821, he informed the public that he had "...removed his saddlery establishment from Daniel Street to his building on State Street where he intended to keep consistently for sale, saddles, bridles, harnesses, trunks."

50. "Thomas Hale at No. 5 Daniel Street. Hats for sale. Gentlemen's & Youths' Drab Beaver Hats also a complete assortment of BLACK HATS… June 2." *Portsmouth Oracle*, June 16, 1821. Hale and his partner Daniel Knight are each cited with $600 stock-in-trade on the 1823–1824 tax lists of Portsmouth, which would indicate that the shop had a significant clientele. Note that Thomas' father operated a hat factory on family property of Belleville, Newburyport, Massachusetts, until his death in 1836.

51. The initial identification was made by Tom Hardiman, Keeper, The Portsmouth Athenæum. See *New Hampshire Observer*, September 27, 1827 and November 19, 1828, for advertisements of Morrison's business on Daniel Street.

52. *Portsmouth Journal*. December 23, 1826.

53. Richard M. Candee, *Building Portsmouth*. 1992, p. 80. A recreated drawing of the steeple is illustrated by C. S. Gurney in his book *Portsmouth Historic and Picturesque*. Portsmouth, New Hampshire: 1902. Peter E. Randall, reprint, p.139.

54. *Joshua & Lydia Johnson to John S. Blunt, painter, westerly half of lot together with the westerly half of the house and one half of the other building on lot for $550.00.* Property transaction deed No. 238–277, November 4, 1822. Recorded Rockingham County Courthouse, Brentwood, New Hampshire. The other half of the property was purchased and occupied by the artist's widowed mother Mary Drowne until her death in 1829.

55. JSB 1819 Account Book. For entry, see Robert Bishop "John S. Blunt," *Antiques* (November, 1977) p. 969.

56. Esther's father Joseph, son of Jacob Colby and Sarah Merrill, was born in Newtown, New Hampshire, September 19, 1777. His younger brother Eastman Colby, born September 21, 1785, is cited as a resident on the 1820 Newton, New Hampshire census. An 1825 "Friendship book" kept by Esther's younger sister Charlotte Colby includes tributes by Amos Tilton, East Kingston, and Anna

Gale, Newtown, New Hampshire (Collection of The Portsmouth Athenæum, S0895, Gift of Linda Jane Rebeck). In 1853, Blunt's younger brother purchased property there.

57. Donna-Belle Garvin and James L. Garvin, *On the Road North of Boston. New Hampshire Taverns and Turnpikes 1700–1900*. Hanover, New Hampshire: University Press of New England, 1988, p. 65.

58. Letter addressed to his wife "Mrs. Esther P. Blunt, Haverhill, Massachusetts." Private collection.

59. As related by Greenland historian Paul F. Hughes, 2007, the tide mill was initially for grinding corn. However, when the Brackett Academy was built in 1825, two oxloads of shingles were hauled hither from the tide mills.

60. I thank James L. Garvin, New Hampshire State Architectural Historian, Concord, New Hampshire, for suggesting this possible identification. Email correspondence January 21, 2007.

61. Gerald H. Miller, surveyor and cartographer, suggested this site to me, although he explained this type of settlement and wharf activity was not unique to Newfields Landing. Similar waterfront development could be found in many of the small settlements along Great Bay such as Durham and Newmarket, as well as across the Piscataqua River in Eliot, Maine.

62. JSB 1826 Account Book, p. 2–3: "Alfred Haven [invoiced] 21 feet moulding."

63. I thank Elizabeth Aykroyd, Hampton Historical Society, and Tom Hardiman, The Portsmouth Athenæum, for this suggestion.

64. In 1817, the State of New Hampshire granted permission to John Bowles (1765–1837) of Portsmouth to build a wooden grist-mill more than twelve feet in height. John Bowles Papers, The Portsmouth Athenæum, S-384. Reference kindly shared by Richard M. Candee. An advertisement for John Bowles in *Portsmouth Journal of Literature and Politics*. November 22, 1823, confirms the continued operation of this windmill at this site.

65. One possible source of sketches for this painting might be his manuscript ledger book covering the period of June 6, 1821 through October 5, 1826, privately owned. The sketches and the entries in the ledger book will be the subject of a forthcoming publication by the owner.

66. Both ship paintings were given to the Newburyport Marine Society by Captain John Wills's son Rufus. When the society disbanded in 1906, the paintings were given to the Historical Society of Old Newbury, Newburyport. See Captain William H. Bayley

and Captain Oliver O. Jones, *History of the Marine Society of Newburyport, Massachusetts, 1772 to 1906*, p. 373, and photograph of the *Washington* (Figure 4-7) on display, p. 128. As these two ship portraits are stylistically related to his 1815 *Launching of the United States Ship Washington* (Figure 4-26), it raises the question of whether Blunt left Portsmouth to work in Newburyport before beginning his Boston apprenticeship with Penniman.

67. Ship portrait with frame commissioned by Ichabod Goodwin's partner and part owner Samuel E. Coues. Cited in JSB 1826 Account Book, p. 10.

68. "Notice to Mariners. A LIGHT-HOUSE has been erected on White Island." *New Hampshire Gazette*, December 15, 1820. See Jane Molloy Porter, *Friendly Edifices. Piscataqua Lighthouse and Other Aids to Navigation 1771–1939*. Portsmouth, New Hampshire: Portsmouth Marine Society, 2006, p. 119.

69. I thank surveyor Gerald H. Miller for identifying the subject of this sketch.

70. Information kindly shared by Jane Porter, email correspondence June 5, 2006. For further details see Porter, p.109.

71. Family legend maintains Captain John Blunt was the pilot who steered George Washington on his famous 1776 Delaware crossing. See Charles W. Brewster, *Rambles about Portsmouth*, first series (Somersworth, New Hampshire: New Hampshire Publishing Co. facsimile 1873 edition, 1971) p. 266. "Farm at Little Harbor, property of Captain Blunt. To be sold Dec. 9, 1800." *New Hampshire Gazette*, December 9, 1800. Note Blunt's Island is part of Rye, not New Castle.

72. This could be a view taken from Upper Cove of the Bos'n Allen house (now razed), the Curtis Hotel (now razed) and the Maxam house (still standing). Information kindly shared by Deb Schulte, New Castle Town Historian, email correspondence January 30, 2007.

73. Nathaniel Adams. *Annals of Portsmouth*. Portsmouth, New Hampshire: C. Norris, 1825. Reprint by Peter E. Randall, 1971, pp. 378–379.

74. For further details see Eric C. Stoykovich, "Bridge over Troubled Waters: Dover vs. The Proprietors of the Portsmouth Bridge 1815–1845," *Historical New Hampshire* (Vol. 59, No. 2) pp. 92–112.

75. Provenance of the painting is as follows: George Massey Marsh (1805–1878), 54 State Street, Portsmouth, New Hampshire. Upon his death, his effects sold at public auction December 14, 1878, by H. F. Wendell, Portsmouth [size cited 5 × 8 feet]. Purchased by William H. Sise. Gift to City of Portsmouth, 1878.

Aside from the size citations, there are some discrepancies about the dating of this painting. *Portsmouth Daily Evening Times* cites the painting twice: on December 16, 1878 it cites it as done in 1826, and on December 20, 1878, it is cited as "painted by J. S. Blunt in 1830." No signature or date has been detected on the canvas, and an earlier aluminum backing prevents examining the back of the canvas for any inscriptions. A subsequent call for subscriptions for "Lithographic Print of Portsmouth" citing a view of this description appears to be unsuccessful as no such prints have been located. (*Portsmouth Journal of Literature and Politics*. January 1, 1831. Vol. XLII, No. 1, page 3).

76. The concept of making monumental views like this might have been inspired by Alvan Fisher, who executed a number of topographical landscapes using preparatory drawings completed outdoors at the location to be painted. His preparatory drawing and painting for his 1818 *View from Gallows Hill* are in the collection of Peabody Essex Museum.

77. The event was one of great fanfare. As the *Washington* went down the ways, she was greeted with a federal salute from the navy yard, which was answered from Fort Constitution and the armed ships *Harpy* and *America* lying in the harbor (*Portsmouth Oracle*. October 8, 1814). The ship on the right is often cited as the Portsmouth-built frigate *Congress* which at that time is documented as being laid up. For more details of the October 1 launching, see Linda M. Maloney, *The Captain from Connecticut. The Life and Naval Times of Isaac Hull*. Boston: Northeastern University Press, 1986, pp. 252–254. For more background on the painting see Nancy Carlisle, *Cherished Possessions. A New England Legacy* (Boston, Massachusetts: Society of New England Antiquities, 2003) 240–241. For detailed discussion of the attribution to Blunt as well as an excellent overview of Blunt's career, see John Wilmerding, *A History of American Marine Painting* (Boston, Mass.: Peabody Museum of Salem and Little, Brown and Company, 1968), pp. 148–150.

78. Jonathan Folsom (born Exeter, New Hampshire 1785–1825) was the Portsmouth carpenter whose services were later engaged for the construction of White Island lighthouse. See Porter, p. 111

79. *History of the Portsmouth Navy Shipyard Portsmouth, New Hampshire 1800–1958*. "From Sails to Atoms," OPNAV Report 5750-5, p. 4. On deposit at The Portsmouth Athenæum.

80. Honorable Levi Woodbury (1789–1851) by descent to his daughter Mary E. Woodbury (1831–1883); her son Woodbury Blair (1852–1933); Blair's wife's nephew Edward Alexander Mitchell; his son Edward Alexander Mitchell Jr. (1924–1975); Adam A. Weschler & Son auction, Washington, DC, October 6–8, 1972, lot 607, illustrated pl. 71. Although there are no paintings of this description cited in JSB 1826 Account Book, some pages are missing. It is also possible the artist kept a separate record of this painting, now lost.

81. *New Hampshire Patriot and State Gazette*, Concord, New Hampshire, Vol. XVI, No. 801. August 9, 1824.

82. Two other likenesses of Negus; a second self-portrait and a portrait by John Robinson in ink and watercolor are illustrated: *Meet Your Neighbors. New England Portraits, Painters and Society 1790–1850*. Old Sturbridge Village, 1993, pp. 115 and 117.

83. Nathan Negus Memorandum Book for 1819, 1820 and 1821. Negus Papers, Archives of American Art, Smithsonian Institution, microfilm #611.

84. In his diary entry for January 1820, Negus was in Boston as he mentions drawing "Mr. Penniman's head in India ink" and later in September that year he is working in Keene, New Hampshire. Nathan Negus diary 1819–1822. See Agnes Dodds. "Nathan and Joseph Negus, itinerant painters." *Antiques* Vol. 76 (November 1959) pp. 433–436.

85. Reference supplied by Tom Hardiman, Keeper, The Portsmouth Athenæum.

86. Few details of Ploomy or Plumy's life are known. She is buried in Mount Auburn cemetery, Cambridge, Massachusetts, alongside her husband Alfred M. Blunt (1813–1888), the artist's younger brother. On her tombstone, she is simply cited as "Plumy" born 1817. Family papers cite her place of birth as Newburyport, Massachusetts, but no birth or death records have been found. In the 1880 Boston, Massachusetts Federal Census, she is cited as age 64, born in Massachusetts, living with spouse Alfred M. Blunt age 66, *pianofinisher*, and daughter Fanny A. Blunt, age 31, 3 servants. (Series T9, roll 555, p.452)

87. In 1821, Joseph Colby is residing on Pleasant Street in Boston at rental property owned by Elisha Copeland. See 1821 Tax List of Boston, Massachusetts. Real estate valued at $200. His landlord and neighbor Elisha Copeland's property is valued at $1,600. Note that Joseph's first wife according to family tradition was Mary Peake, but her actual dates and place of birth and death have yet to be verified.

88. Marriage notices appeared *Boston Daily Advertiser*, October 10, 1821, Vol. 33, No. 30, p. 2; *Columbian Centennial*, October 10, 1821, p. 2, issue 3913; *New Hampshire Gazette*, October 16, 1821, p. 3, col. 3; *Portsmouth Journal of Literature and Politics*, October 13, 1821, p. 3, col. 3.

89. Portsmouth-born Sarah is cited as an attendee at the 1823 Centennial Ball in Portsmouth. She is buried with her husband and son Nathaniel in South Street Cemetery, Portsmouth, New Hampshire.

90. Reference kindly shared by owner of JSB 1819 Account Book, email correspondence March 27, 2007.

91. Nina Fletcher Little, "J. S. Blunt, New England Landscape Painter." *Antiques* Vol. 54, No. 3 (September 1948) p. 172.

92. A sample set of fancy chairs currently on view at Rundlett-May Mansion, Portsmouth, New Hampshire (Collection Historic New England, 1971.477.f), are illustrated *Portsmouth Furniture Masterworks from the New Hampshire Seacoast*, p.360, figure 99A.

93. *Commercial Advertiser*, Thursday, August 23, 1827, p. 3, col. 2. A raffle of Blunt paintings to be held at The Portsmouth Athenæum. When he packed up his studio in 1835, *View of Notch of the Mountains* is cited as one of the paintings for sale (Figure 1-6).

94. "Exhibition of Paintings," *Portsmouth Journal*. October 18, 1828.

95. Tracie Felker, "Charles Codman: An Early Nineteenth-century Artisan and Artist," *The American Art Journal*, Vol. XXII, No. 2 (1990) pp. 61–83. If Codman's dating of his painting is an indication of when he did the sketch, is it possible Blunt's drawing (Figure 5-4) of July 4, 1821, was done on a trip to the White Mountains with Codman? Other than Blunt's travels with William P. Codman in 1819, and the fact Blunt and Charles Codman served as apprentices together in Penniman's workshop, little is known.

96. Kim Sloan, *Alexander and John Robert Cozens. The Poetry of Landscape*. New Haven: Yale University Press, 1986.

97. Carol Damon Andrews, "John Ritto Penniman (1782–1841), an ingenious New England artist," *The Magazine Antiques* Vol. 120 (July 1981) pp. 147-171. Edward S. Smith. "John Rubens Smith. An Anglo-American Artist," *Connoisseur* (Vol. 85). May 1930, pp. 300–307.

98. Catharina Slautterback, *Boston 1735–1818*. Exhibition catalog. Boston, Massachusetts: Museum of Fine Arts. April 18–October 12, 1975, p. 299.

99. In Portland, Maine, things were no better. As art patron John Neal remarked, "…his pictures [Charles Codman's] are to be found in most of our houses…but the mischief is that they have always been painted for nothing, or sold for nothing. The artist is always living from hand to mouth." Jessica Nicoll, "The Real Pioneer of Art in this City: Charles Codman and the Rise of Landscape Painting in Portland, Maine," *Charles Codman*, p. 51.

100. Blunt's involvement with the printing industry warrants further investigation. As early as 1822, he was selling prints of the New Hampshire State House [Concord] at his painting rooms on Daniel Street. The prints were "for sale by the subscriber—also one dozen elegant Fancy Chairs. John S. Blunt, Daniel Street. December 18"(*New Hampshire Gazette*. Vol. LXVII, No. 6, p. 1, January 1, 1822). An 1831 notice asking for subscribers for a "Lithographic View of Portsmouth to be taken from the North West, including a view of the town, the whole breadth of the Piscataqua River, part of the Portsmouth bridge, Navy-Yard, Forts Washington, Sullivan & c. & c." (*New Hampshire Gazette*, February 5, 1831), which appears to be based on Blunt's *View from Freeman's Point*, was never executed.

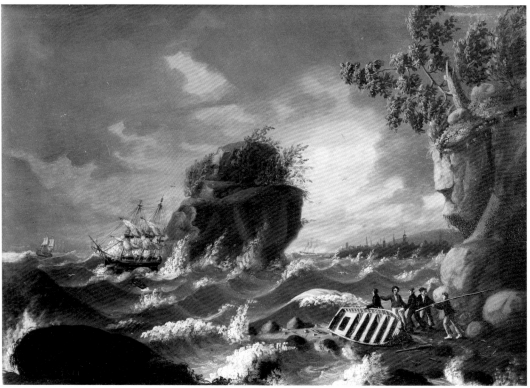

John Samuel Blunt
Stormy Scene
Signed on lower left "J. S. Blunt 1822"
Oil on panel
22 × 15 ½ inches.
Private collection

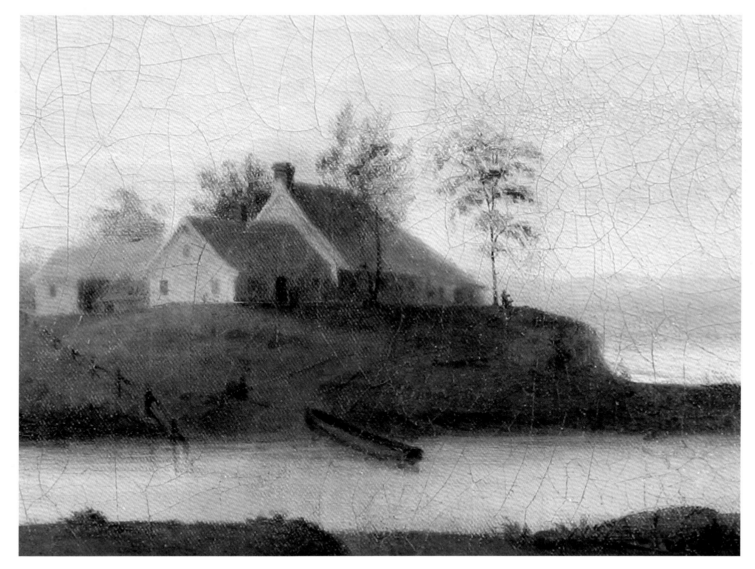

Detail of Figure 4-16.

About the Author

Deborah M. Child is an independent art historian and museum consultant based in Portsmouth, New Hampshire. She is a graduate of The Master of Arts program at Queen's University, Kingston, Ontario, Canada. For the last five years she has been researching Piscataqua painting of the Federal period, with a special interest in genealogy and provenance searches. Since 2005, she has been project curator for the John Samuel Blunt Catalogue Raisonné Project at The Portsmouth Athenæum.

Visit www.portsmouthathenaeum.org/blunt for details.

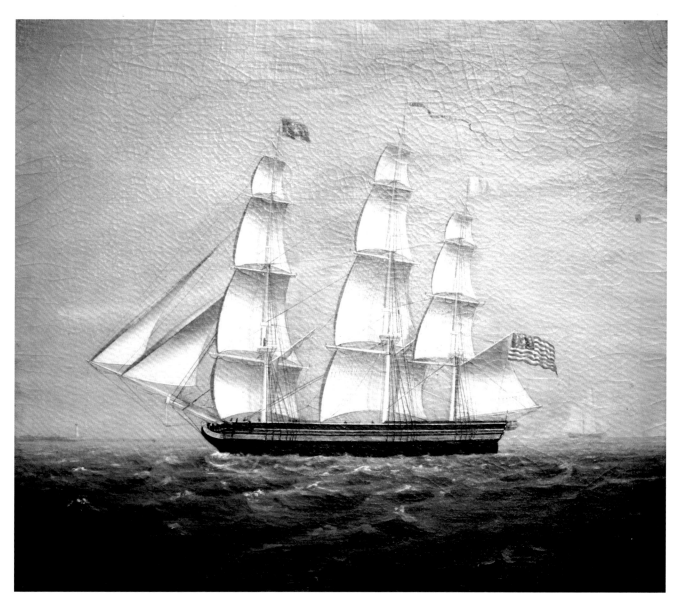

Sarah Parker
Signed lower right "John S. Blunt 1827"
Oil on mattress ticking
28 x 32 inches
Strawbery Banke Museum
Gift of Eleanor R. Snelling
Ship portrait with frame commissioned by Goodwin's partner and part owner
Samuel E. Coues. Cited in JSB Manuscript Ledger Day Book, 1826–1835
(Collection Portsmouth Athenæum, S855, p. 10).